NORTH COTSWOLD PUBS

THROUGH TIME

Geoff Sandles

AMBERLEY PUBLISHING

In memory of my Dad, Mervyn Sandles, 1928–2011.
Thanks for buying me that pint back in 1973.

First published 2012

Amberley Publishing
The Hill, Stroud
Gloucestershire, GL5 4EP

www.amberley-books.com

Copyright © Geoff Sandles, 2012

The right of Geoff Sandles to be identified as the
Author of this work has been asserted in accordance
with the Copyrights, Designs and Patents Act 1988.

ISBN 978 1 4456 0401 5

British Library Cataloguing in Publication Data.
A catalogue record for this book is available from
the British Library.

Typeset in 9.5pt on 12pt Celeste.
Typesetting by Amberley Publishing.
Printed in the UK.

Introduction

Back in the early 1970s, when I was a young teenager with curly long hair, my Mum and Dad would take me camping. I had the rough camping experience whilst Mum and Dad would stay in the comparative luxury of their two-berth caravan. They belonged to the local Camping and Caravanning Club and most weekends were spent on a farmer's field somewhere in the North Cotswolds. I still remember the delights of stepping in freshly laid cow dung in the dark and treading it nonchalantly into the tent.

It was probably in 1973, two years before my legitimate drinking age, that we set up camp for the weekend at Castlett Farm in Guiting Power. Saturday night was spent in the nearby Halfway House at Kineton. In those days it was a two bar pub and I was told to behave myself and sit quietly in the lounge bar. I was expecting to be given the usual bottle of coke and packet of Smiths crisps (with the blue salt sachet), but I was given a glass of beer. It was love at first pint, a wonderful vision in glorious black and white.

I expect that you're thinking that the 'black stuff' I refer to was Guinness with a nice white creamy head. Actually, it was the pub sign that I had seen outside the pub. In bold white letters on a shiny black background it had two life-changing words, 'Donnington Ales', and whatever this stuff was it tasted fantastic. At home my Dad had treated me to the occasional half pint bottle of Whitbread Pale Ale, but here I was in a pub drinking beer like a grown up and it was delicious.

On sale at the Halfway House was a booklet which gave descriptions of all the seventeen Donnington pubs and their locations. Until then I'd probably never heard of places like Lower Swell, Ganborough, Broadwell, Little Compton, Ford and Snowshill. But I had a pushbike and I was going to use it.

By the time the 1970s had drawn to a close I had cycled to all the Donnington pubs in the North Cotswolds and got 'the taste' for their

BB, SBA and XXX mild. My Ordnance Survey map reading lessons in school certainly proved useful!

Thankfully, nothing much has changed since then. In fact it's got much better. Donnington Brewery continue to brew excellent beer for their pubs and other North Cotswold inns that sold beers like Whitbread Tankard, Youngers Tartan and Worthington E in the 1970s, and now proudly support independent local breweries like Battledown, Goffs, Prescott, Cotswold Lion and Stanway.

In Spring 2012 local newspapers reported that an alarming 845 pubs had closed in Gloucestershire between 2002 and 2010. The thoroughly depressing figures were apparently obtained from the Office of National Statistics. The validity of such statistics is open to question as many pubs close only temporarily, sometimes being reincarnated as vibrant and successful businesses. The North Cotswolds has seen very few permanent pub closures in the last decade. Freehold pubs in the area are thriving, and Hook Norton brewery in Oxfordshire is actively seeking to purchase their own pubs in the Cotswolds.

On that optimistic note it is gratifying to report that only 10 percent of the pubs illustrated in this book have closed for good. Many others, however, have changed beyond recognition. The old fashioned boozers, offering not much more than beer and skittles, have been replaced by so called gastropubs, dishing out culinary masterpieces with a selection of the finest wines. And there's absolutely nothing wrong with that as long as the emphasis is on serving good food and wine in a pub rather than selling beer in a posh restaurant.

The images in this book are arranged in alphabetical order according to towns and villages, from Andoversford to Woodmancote. For those unfamiliar with the North Cotswolds I would recommend that they visit my website www.gloucestershirepubs.co.uk where you will find additional information on the pubs and precisely where to find them.

Finally may I extend special thanks to those who have helped me with research and providing images and photographs for this book: Derek Arthurs, Tim Edgell, Neil Herapath, Darrel Kirby, Martyn Herbert, Joe Stevens, Michael Wilkes, *Gloucestershire Echo*, David Hanks and the anonymous gentleman who so kindly donated many of the original black and white photographs. Thanks also to my wife Kathy who has been so supportive whilst I have been working on the book.

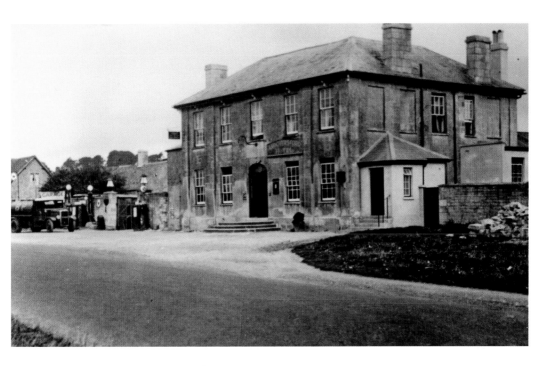

Andoversford Hotel, Andoversford

In 1974 the Andoversford Hotel was included in a book entitled *Inn and Around – 250 Favourite Whitbread Pubs*. It was described, without irony, as having an elegant Georgian façade which belies its modern interior. At that time it was a popular steak restaurant, branded as a Trophy Tavern. When the village of Andoversford was bypassed all passing trade was lost, and the hotel closed in 1988. Huntsmans Meet now occupies the site. The old pub sign now houses the Andoversford village sign.

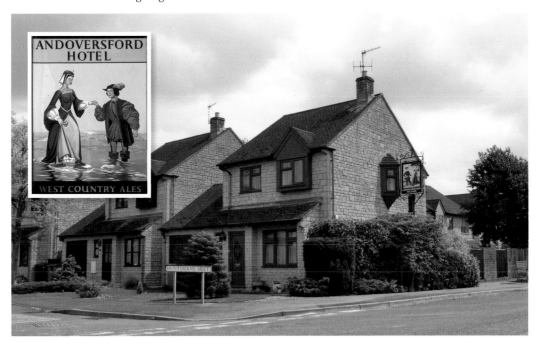

Royal Oak, Andoversford

The Royal Oak was once a tied house of George Stibbs' Cheltenham Steam Brewery in Albion Street, passing into the ownership of the Cheltenham Original Brewery in 1897. An extension to the licence was granted on alternate Fridays when the Andoversford livestock market took place. In the days before the breathalyser cattle trucks, horseboxes and tractors were often seen to be driven erratically through the village late in the afternoon.

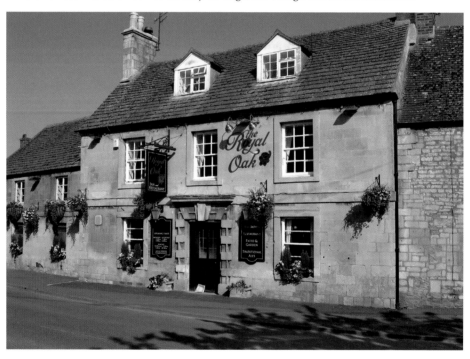

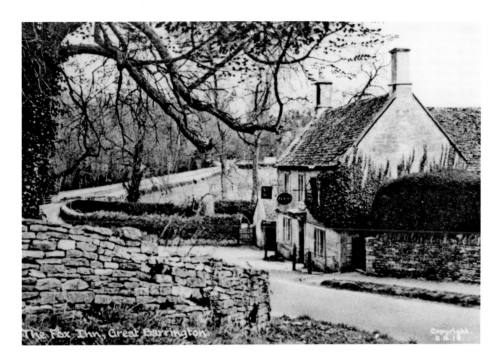

Fox Inn, Barrington

The Fox Inn is located in an idyllic position on the banks of the River Windrush in a beautiful valley. Owned by the Donnington Brewery, it is a true vision of paradise. In recent years landlord Paul Porter has enlarged the pub by adding a riverside conservatory dining bar, two riverside terraces, an outside summer bar, covered and heated outdoor dining areas and seven riverside letting rooms including a bridal suite. Crucially, however, the heritage and tradition of the front public bar has been retained.

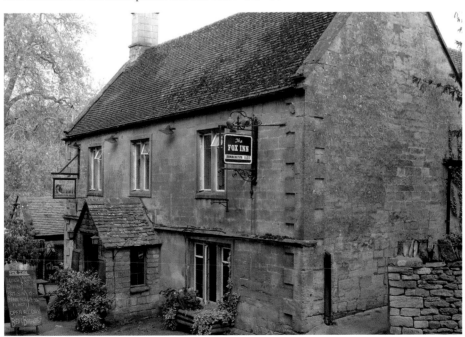

Inn For All Seasons, Barrington

The unusually named Inn For all Seasons is located on the main A40 trunk road about two miles to the west of Burford. Its position would suggest that it once served as an important coaching inn. However, in 1903 when it was known as the New Inn, the sixteenth-century building had a comparatively low rateable value of just £12 per annum and was restricted to opening just six days a week. The Inn For All Seasons now has ten *en-suite* rooms and specialises in sea food – despite being eighty miles from the sea.

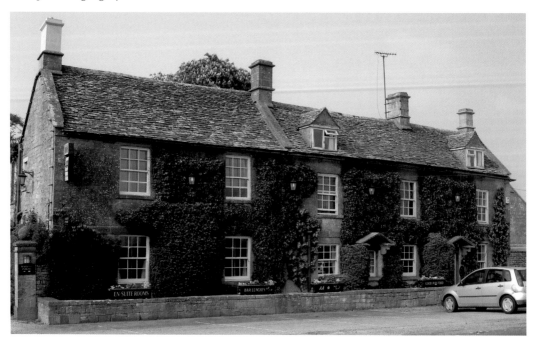

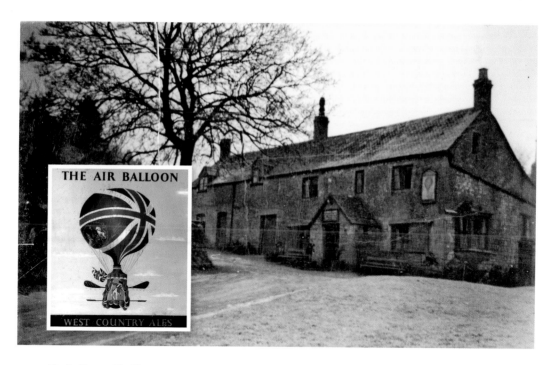

Air Balloon, Birdlip

The pub probably takes its name from the pioneering balloon flights that took place on the Cotswold escarpment in 1784, just a year after the Montgolfier brothers first took to the air in a balloon in Paris. The pub was known as the Balloon in 1796 and had become the Air Balloon in 1802. The landlord in 1856, Richard Tuffley, was brewing home brewed ale on the premises. The Air Balloon now overlooks one of the busiest roundabouts in Gloucestershire where the A417 meets the A436 – the direct link from the M4 to the M5.

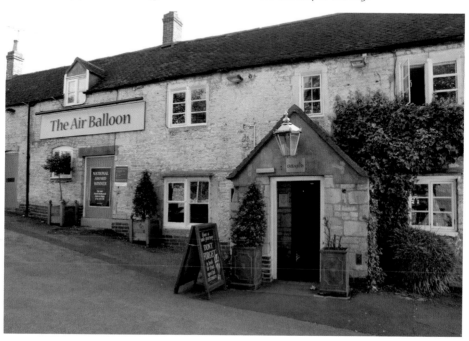

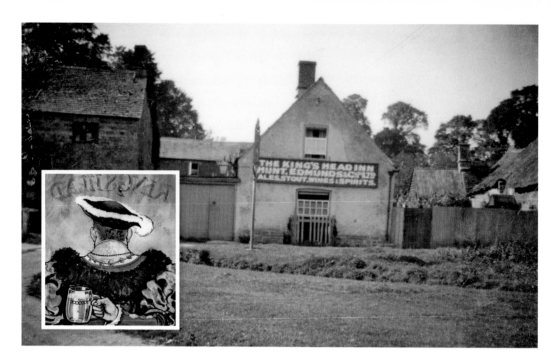

Kings Head, Bledington

The sixteenth-century stone-built Kings Head is located in an idyllic position on the village green with a small stream running through the grounds. The pub was chosen to grace the front cover of the *Good Food Guide 2012*. To celebrate the passing of the millennium three locals had a contest to see who could grow the largest and most beautiful moustache. The contestants doused their whiskers regularly in Hook Norton beer in an attempt to spur on growth that would lead to a 'hair-roic' victory!

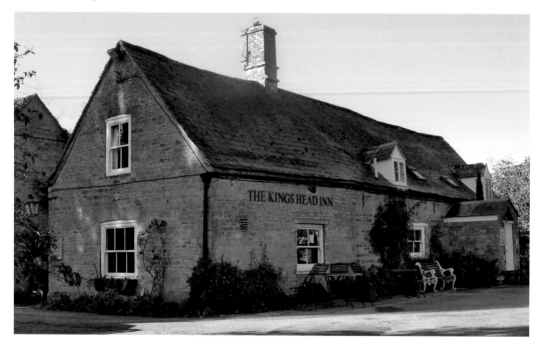

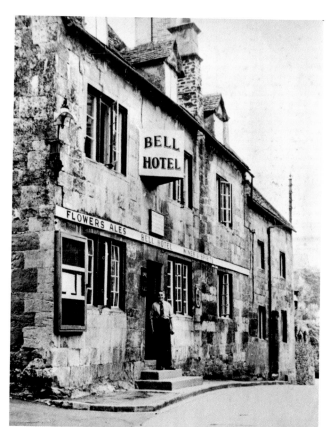

Bell Inn, Blockley
Formerly the home of the wealthy Walgrove family, the sixteenth-century house became the Bell Inn in 1712. The clubroom to the rear of the pub was used by the Blockley Brass Band for practice. The Bell Inn was occupied by the US 6th Armoured Division from February to June 1944. It is now converted into residential flats.

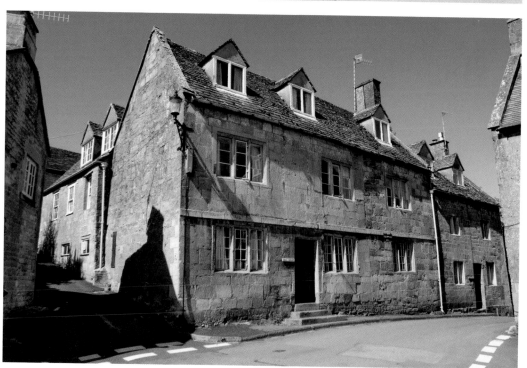

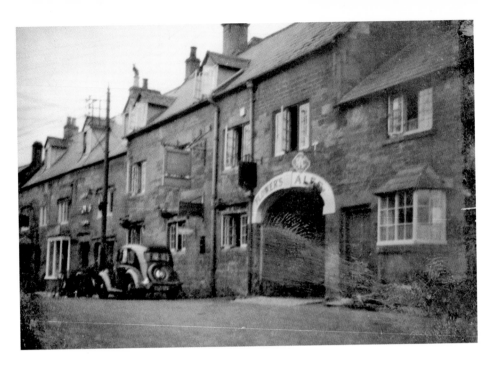

Crown Inn, Blockley

Prior to 1931 Blockley was part of Worcestershire and in February 2002, during the filming of the BBC 1 crime series *Dalziel and Pascoe*, the picturesque Cotswold village was set in a Yorkshire landscape. Four years later a real life drama unfolded at the Crown, making headline news. When a local thug took a red hot poker from the fire and branded obscenities on the plush carpet the landlord retaliated by banning the entire residents of Blockley from the Crown.

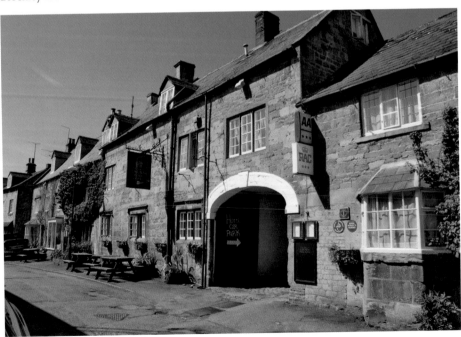

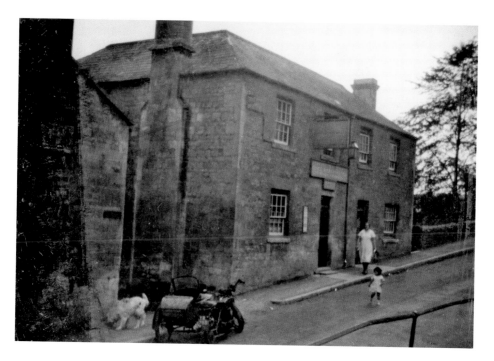

Great Western Arms, Blockley

The Railway Inn was first licensed for the navvies constructing the Oxford, Worcester and Wolverhampton Railway in the mid-nineteenth century. In the early 1990s the pub, trading as the Great Western Arms, was sold to the Hook Norton Brewery. 'Hooky' beers have been brewed in Hook Norton since 1849 in the classic Victorian tower brewery, complete with a working 25-hp steam engine. At the time of writing (June 2012) the Oxfordshire based brewery are looking to acquire more pubs in Gloucestershire. They currently have just two.

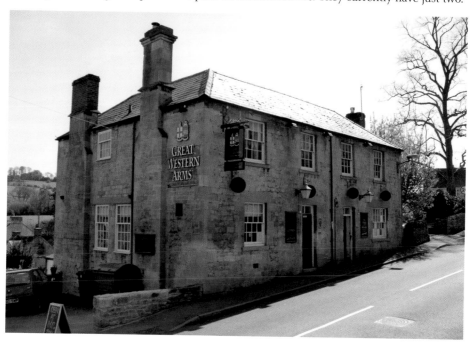

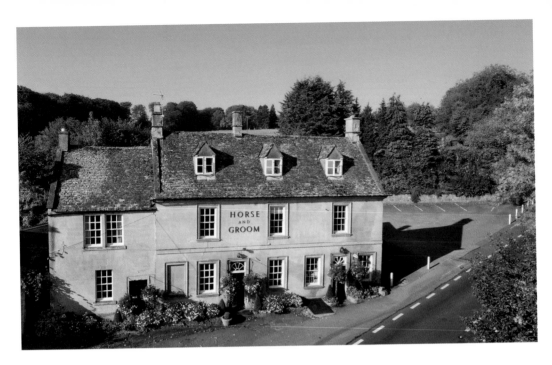

Horse and Groom, Bourton-on-the-Hill

In February 2005 an application was submitted to the Cotswold District Council for change of use to a private house. Disgruntled villagers, angry that their village pub had ceased serving food and was only opened for eleven hours a week, rightly objected claiming that the owners had deliberately run the pub down. A petition, followed by a public meeting attended by nearly 100 people, was enough the make the owners withdraw the application. The Horse and Groom is now thriving again under new owners.

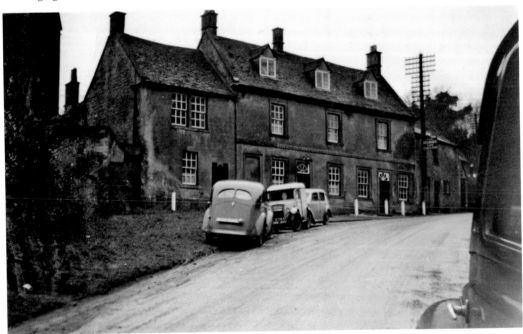

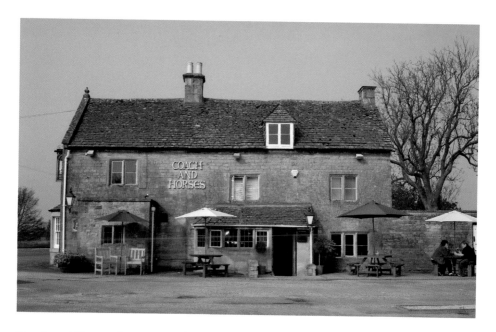

Coach and Horses, Bourton-on-the-Water

The seventeenth-century pub is located on the A429 Fosse Way on the western side of the picturesque village of Bourton-on-the-Water. As its name suggests, the Coach and Horses was once a coaching inn – although of modest proportions. A tripling of the rateable value in the twelve years from 1891 to 1903 would suggest that the pub was enlarged in that period. In 2001 one of the old stable blocks at the back of the inn was converted to letting rooms. The Coach and Horses was totally refurbished in 2009. The website states that the inn 'retains much of its original charm with oak beams, stone mullion windows, Cotswold stone walls and roaring log fire for those chilly winter evenings. The décor has a rustic and contemporary feel providing a relaxed and atmospheric environment to enjoy exceptional food prepared using fresh local ingredients.'

Duke of Wellington, Bourton-on-the-Water

Now owned by Wells & Youngs and selling Charles Wells Bedford Ales, the Duke of Wellington was once tied to Dunnell & Sons of Banbury. The opening of the Bourton-on-the-Water branch line in 1862 meant that the Oxfordshire brewery could extend their trading area westwards. On the day the railway came to Bourton, the landlord of the Wellington, Mr Stokey, was so excited he wrote a song about the occasion. One verse went: 'The morning was fine and at 9 a.m. to the minute, to travel by steam we did begin it.' A true 'Shakesbeerian' masterpiece!

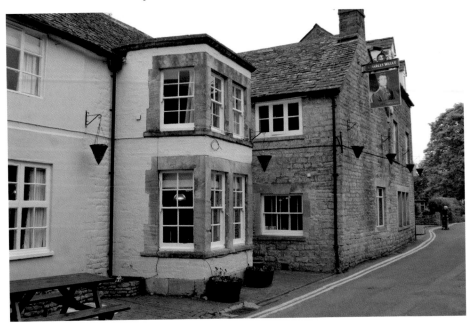

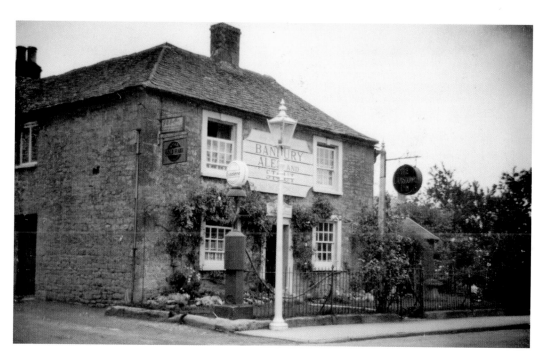

Mousetrap Inn, Bourton-on-the-Water

Originally called the Lansdown Inn, the popular nineteenth-century Mousetrap Inn is located at the western end of Bourton-on-the-Water away from the hustle and bustle of the main tourist area. The Mousetrap Inn was once tied to Hunt Edmunds Banbury Brewery, but now operates as a traditional free house run by father and son team David and John Bates. Real ales from small Gloucestershire breweries are usually on offer.

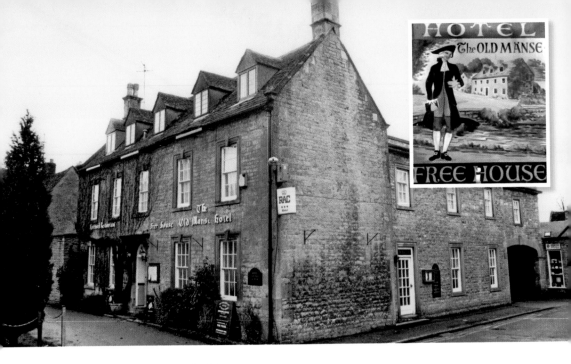

Old Manse, Bourton-on-the-Water

The Old Manse Hotel, a former manse of Baptist minister Benjamin Beddome, is in an idyllic position on the banks of the River Windrush overlooking an attractive three-arched Cotswold stone bridge. It really is classic picture postcard stuff – the quintessential English village scene.

In July 1999 the Old Manse held an unusual charity racing event – Yorkshire pudding racing! The winner won a bottle of champagne and there were booby prizes for the first pudding to sink and a gift for any Yorkshire pudding that was eaten by a duck!

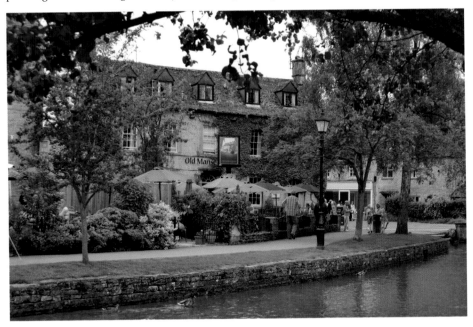

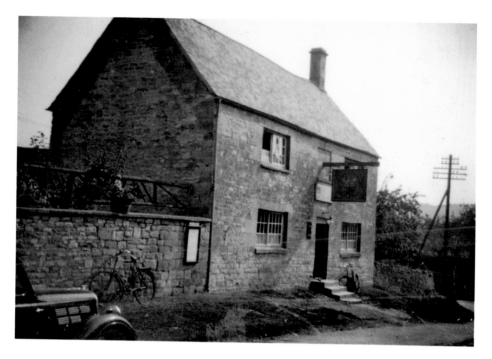

Bakers Arms, Broad Campden

Set in one of the most picturesque villages in Gloucestershire, and arguably England, the Bakers Arms is a fine example of an traditional unspoilt English pub. The Bakers Arms, a delightful honey coloured Cotswold stone building dating back from 1724, was the CAMRA Gloucestershire Pub of the Year in 2005. On one wall there is a tapestry of the pub, a hand-woven rug made in the late 1960s when the Bakers Arms was tied to Whitbread.

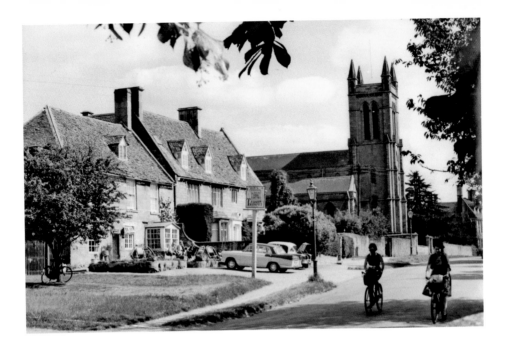

Crown and Trumpet, Broadway

Broadway is the quintessential picture-postcard Cotswold village and is justifiably a popular tourist location. The Crown and Trumpet, a seventeenth-century stone inn situated behind the village green by the church, is a classic unspoilt pub with Flowers Brewery memorabilia on display. The nearby Stanway Brewery brews beer especially for the pub, with guest beers usually sourced from Gloucestershire craft breweries. The Crown and Trumpet is currently Shakespeare Branch of CAMRA Pub of the Year 2012. Broadway will eventually be served by steam trains on the Gloucestershire-Warwickshire railway, a vision of absolute utopia.

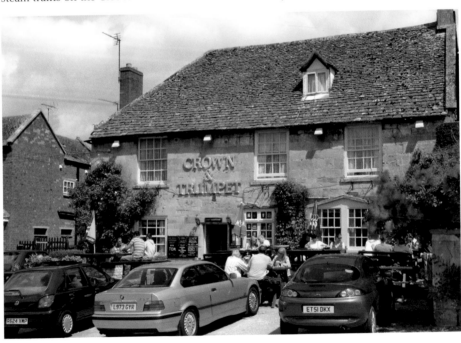

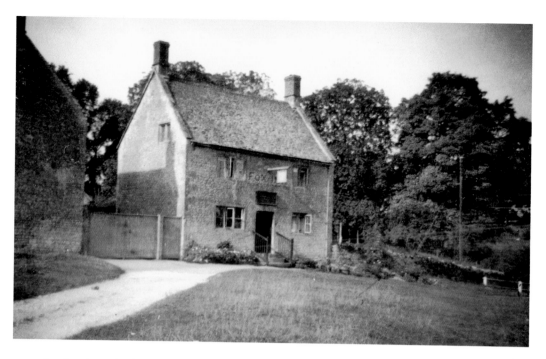

Fox Inn, Broadwell

The Cotswold stone Fox Inn, overlooking the spacious village green, is one of the celebrated fifteen Donnington Brewery pubs. However, in 1903 the Fox Inn was owned by the rival Green's Stow Brewery of Park Street which closed in 1914 following the acquisition by the Cheltenham Original Brewery. Every Christmas a carol service is held at the Fox Inn when nearly 100 villagers cram into one room. The start of the proceedings is announced by a blast from an antique car horn.

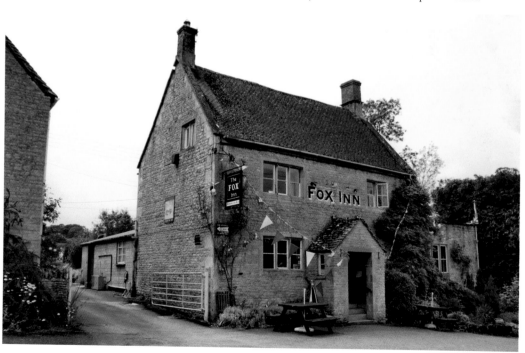

Craven Arms, Brockhampton

Tucked away down a narrow lane in the village of Brockhampton, the Craven Arms can be difficult to find for the first time visitor. It is well worth visiting as it is currently the North Cotswold Branch of CAMRA Pub of the Year for 2012. Just a few yards away from the pub is a building with a large chimney. This was once the Combe's Brockhampton Brewery, which diversified into the production of early 'home-brew' kits. Surprisingly, the Craven Arms never sold beer from the Combe's Brewery.

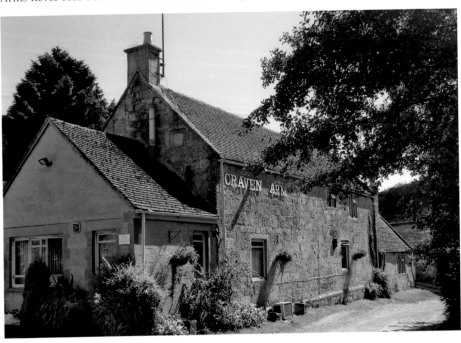

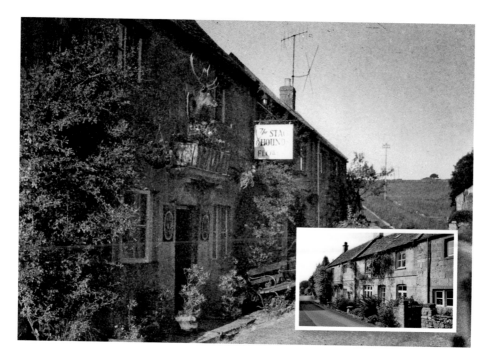

Stag & Hounds, Brockhampton

Now a private house called Hunters Rest, the Stag & Hounds was at the top end of Brockhampton village near the quarry. The building can be easily recognised as it still retains the metal wall bracket from where the pub sign once hung. The Stag & Hounds is mentioned in a 1961 booklet produced by Flowers Stratford-upon-Avon Brewery entitled 'where to pick Flowers in the Midlands', but closed down shortly afterwards probably because of lack of car parking.

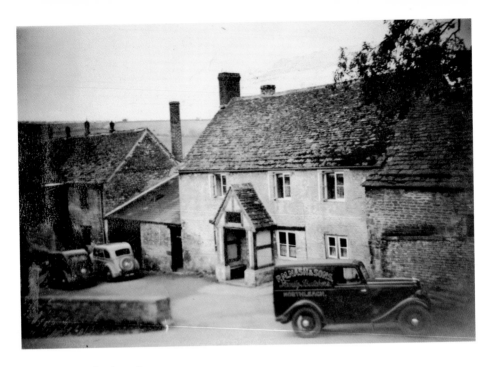

Seven Tuns, Chedworth

The Seven Tuns was tied to the local Cirencester at the beginning of the nineteenth century, then through brewery takeovers it passed into the ownership of Simonds of Reading and then Courage. After the closure of the Courage Bristol Brewery the Seven Tuns was sold to Smiles, also of Bristol, but their sudden expansion into the property market caused financial problems. Smiles was acquired by London brewers Youngs. In 2006 they ceased brewing themselves and transferred beer production to Bedford.

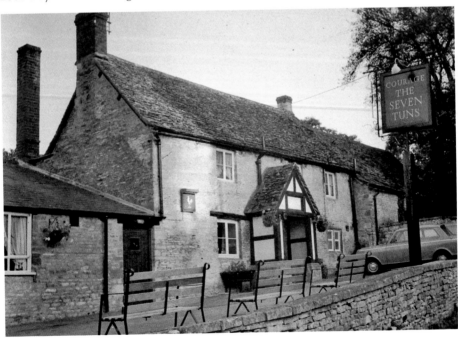

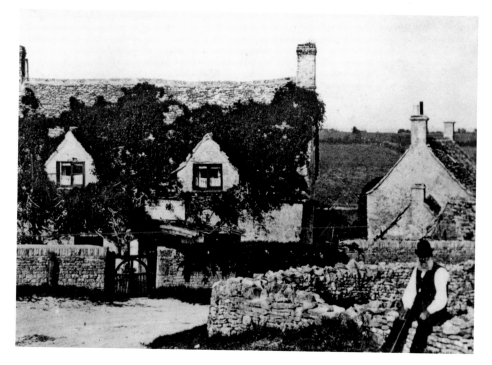

Smuggs Barn, Chedworth

Smuggs Barn, at the top of School Hill and near the Village Hall, ceased to be a pub in 1927. Although the contemporary licensing records of 1891 and 1903 state that the Smuggs Barn was owned by the Cirencester Brewery it is also known that beers were once supplied by the Nelson Home Brewery in Cirencester. Cider was also produced at Smuggs Barn. There are tales, probably started by inebriated locals, of contraband goods being stored at the pub arriving from Gloucester Docks.

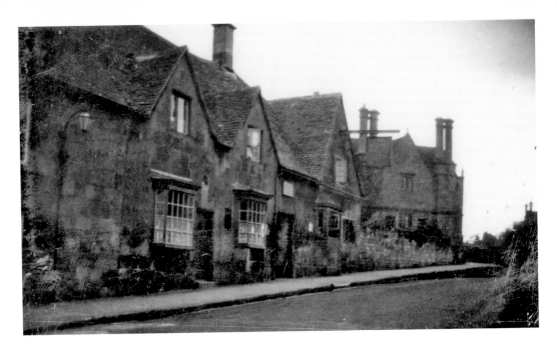

Eight Bells, Chipping Campden

The Eight Bells is a delightful honey coloured fourteenth-century Cotswold stone inn with a cobbled courtyard. It was once tied to Lardner & Sons Compton Steam Brewery of Little Compton, before becoming a Flowers Stratford-upon-Avon pub and then passing into Whitbread ownership. The Eight Bells had a famous visitor for Sunday lunch on 1 April 2007 when Paul McCartney and his daughter Heather called in. Apparently the pub juke box was playing the Beatles' song 'Eight Bells a Week!'

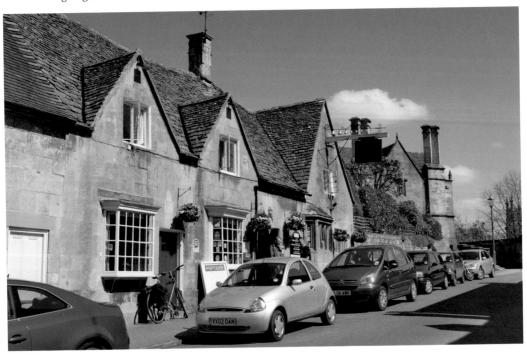

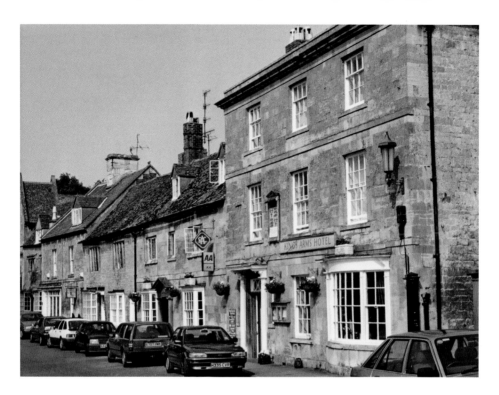

Kings Arms, Chipping Campden

I was intrigued to discover that the Kings Arms in Chipping Campden was owned by Richard Arkell's Donnington Brewery in 1891. The present Kings Hotel in the High Street, a well appointed establishment – certainly not for the riff raff – would have been a great Donnington's pub. Further research revealed that the present day Kings Hotel did not become licensed until 1935, the original Kings Arms (now Caminetto) was refused a licence in 1891 the 'premises being in a dilapidated condition and not fit for a public house'.

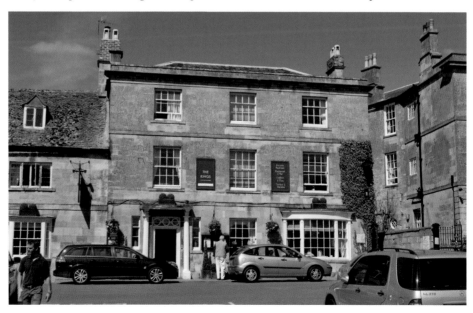

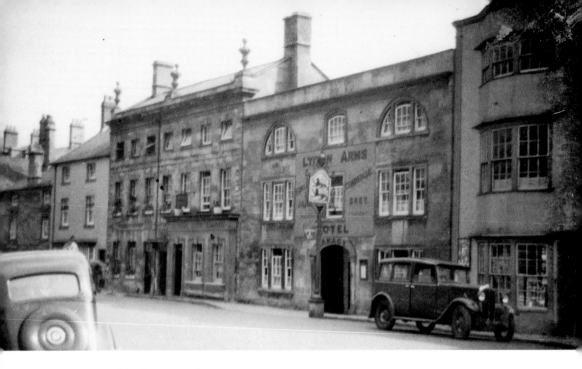

Lygon Arms, Chipping Campden

The Lygon Arms has a history that can be traced back to the sixteenth century when it was a coaching inn trading as the White Hart. It later became the Hare & Hounds before changing its name to the Lygon Arms. It was named after Major General Edward Pyndar Lygon (1786–1860), who fought at the Battle of Waterloo in 1815. Chipping Campden held a three day sprout festival in October 2002, organised by the British Sprout Association. The Lygon Arms served up sprout cocktails including Sprout Royale and the Bloody Brussel Sprout!

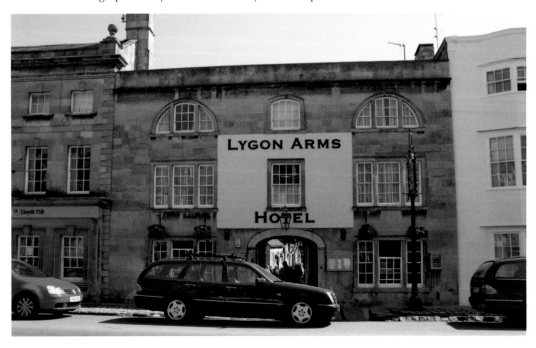

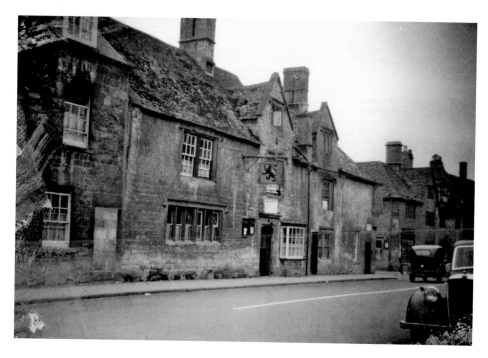

Red Lion, Chipping Campden

The first records of the Red Lion in its present position in the High Street date from 1659 but, prior to that, there was another Red Lion at the northern end of the High Street. Before the First World War the Red Lion was a 'spit and sawdust' pub. Apparently one local could spit from one end of the bar to the other directly into a brass spittoon. Today the Red Lion caters for a rather better class of customer, inviting you to 'sleep where dinner is good, wine is plentiful and breakfast is something to behold!'

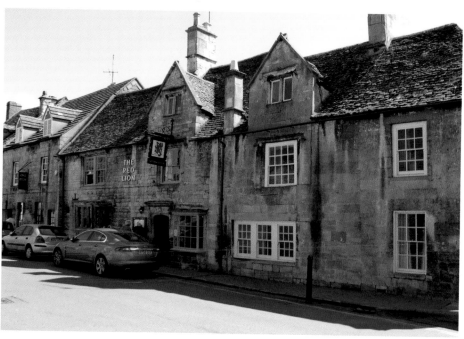

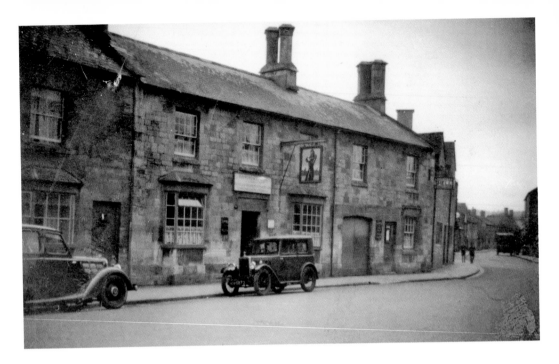

Volunteer, Chipping Campden

A beerhouse was trading at the location of the Volunteer in the middle of the eighteenth century, although its name is not known. The present name was given around 1859 when the pub was used as the signing on place for the Crimean War and later the Boer War. In July 2007 the Volunteer Inn was deluged with up to 3 feet of flood water. In true British spirit the bar kept open during the mayhem, customers drinking with water up to their knees.

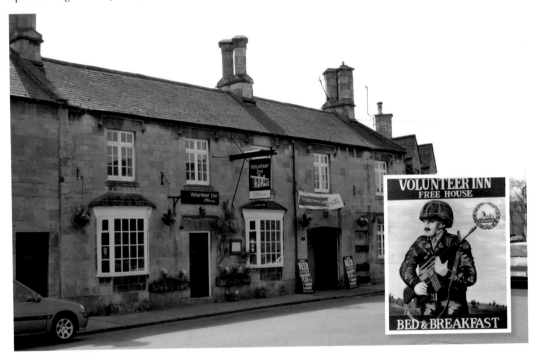

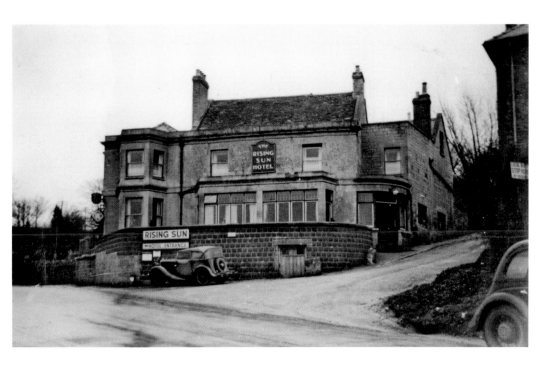

Rising Sun, Cleeve Hill

The Rising Sun Hotel, perched on the edge of the Cotswolds escarpment, commands spectacular views encompassing the Vale of Evesham, the Malvern Hills, Cheltenham and the Forest of Dean. Glorious sunsets can sometimes be seen as the sun sets in the west so, in theory, the inn should have been named the Setting Sun. Now owned by Greene King and offering accommodation in twenty-four *en-suite* bedrooms, there was a time when the Rising Sun was a simple alehouse. In 1856 the landlord Mr Simmonds even brewed beer at the inn.

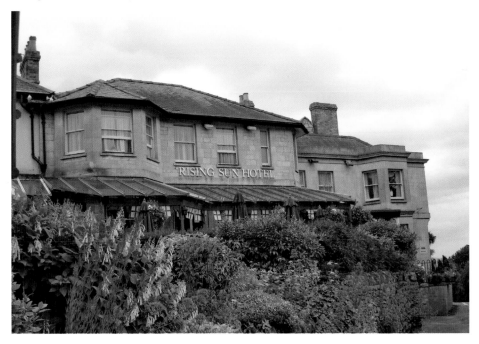

Green Dragon, Cockleford

Located in a valley just off the A435 Cheltenham to Cirencester road, the Green Dragon has been welcoming customers since the mid-seventeenth century. During an extensive refurbishment in 1997 the interior was lavishly fitted by the 'mouse man of Kilburn'. Replicating the skills of the original 'mouseman', Robert Thompson, who made his whimsical furniture in the 1920s, carved mice feature in the furniture and wooden fixtures. On 5 August 2010 the Green Dragon had to be evacuated when two live Second World War bombs, which were found in the nearby stream, were made safe by bomb disposal experts.

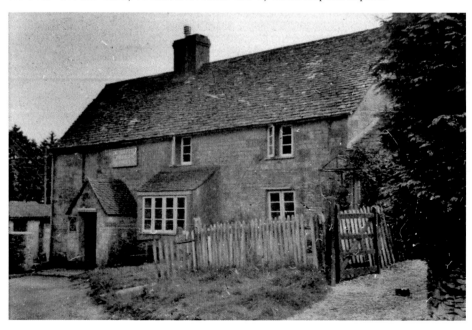

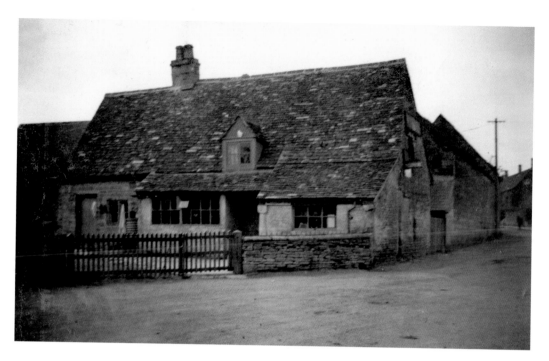

Plough Inn, Cold Aston

The Plough Inn is a small seventeenth-century (built 1678) stone-flagged pub with low beams. It was once a rare outlet for Dunnell's Brewery of Banbury, latterly being owned by Hunt Edmunds and Bass Charrington. In the 1960s it was popular for its 'chicken in the basket' meals and regulars were entertained by pianist Maude – who apparently looked a lot like Les Dawson. It also served as the village post office. Now a free house, the Plough Inn has recently been sold to new owners who intend to build up the food trade.

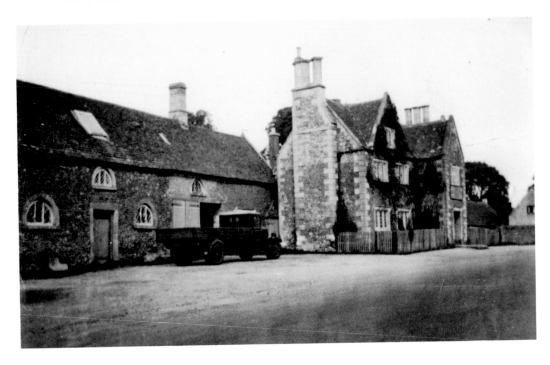

Colesbourne Inn, Colesbourne

The Colesbourne Inn has been owned by the Elwes family of Colesbourne Park since it was built in 1827 and leased to the Wadworth Brewery of Devizes since 1962. In 2003 a room in the pub was used as a polling station, an unusual arrangement but not entirely unprecedented. The police held a Community Consultative Meeting in the pub in October 2005. The invitation stated that tea and coffee would be available – as was drinking copious quantities of 6X beer, but that was probably not advisable in the circumstances.

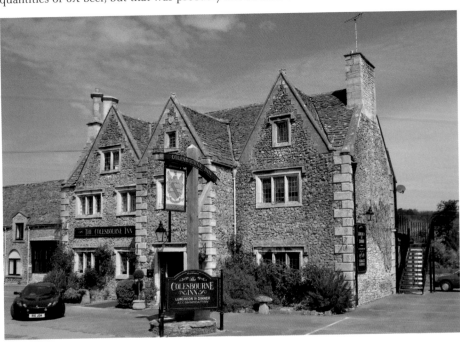

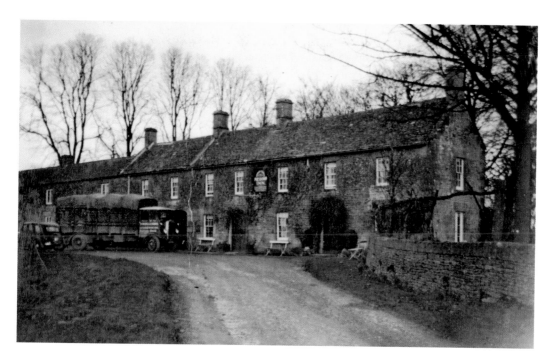

Puesdown Inn, Compton Abdale

The Puesdown Inn, dating from as early as 1236, is in an isolated and high (250 metre) spot on the Cheltenham to Burford (A40) road between the villages of Compton Abdale and Hazelton. Perhaps not surprisingly there have been many tales of ghostly apparitions in and around the pub, probably originating from scary stories told after a few beers around the roaring log fire on cold foggy winter nights. In August 1995 the name changed to the Cotswold Explorer, after Dr Edward Wilson (not a bus ticket!), but had reverted back to the old name two years later.

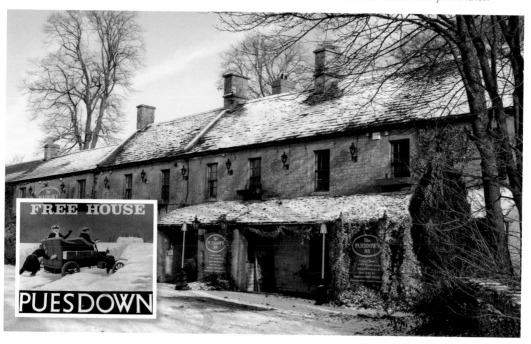

Ebrington Arms, Ebrington

When Jim and Claire Alexander moved into the Ebrington Arms in 2007 after ten years in London in the music business, they had no previous experience in the licensed trade. Within just one year they had gained an AA Rosette for the quality of the food in the pub and secured a listing in the Michelin guide. The beers are good too. The North Cotswold Branch of CAMRA declared the Ebrington Arms their Pub of the Year in 2009, 2010 and 2011 – being narrowly beaten by the Craven Arms in Brockhampton in 2012.

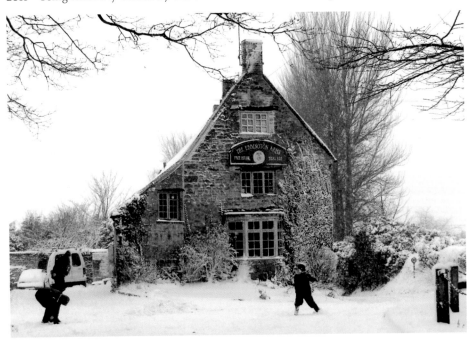

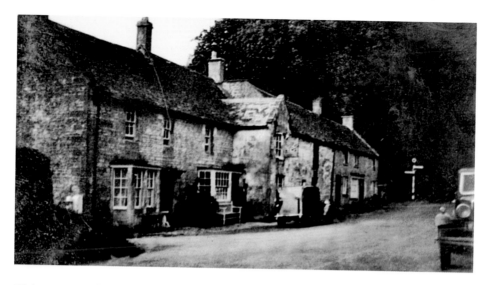

Highwayman, Elkstone

As early as 1781 there was an inn near the turnpike booth on the ancient Ermin Street, the Gloucester to Cirencester road, called the Huntsman and Hounds. By 1856 the name had changed to the Masons Arms. The property was bought by the Cirencester Brewery on 30 May 1919 with 'cottage and land'. When it was enlarged to incorporate the outbuildings the name was changed to the Highwayman Inn, perhaps a suitable choice given its isolated location. In 1997 the front entrance to the pub was severed when the dual carriageway was constructed, access is now via a side road.

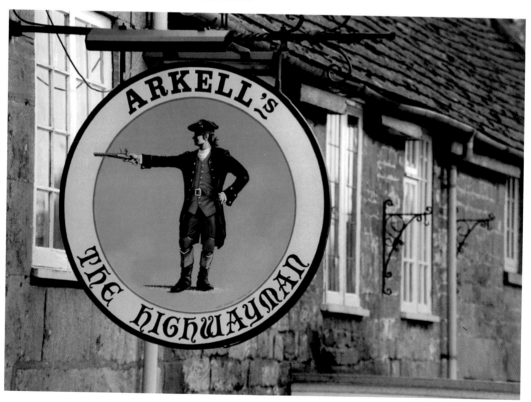

Plough Inn, Ford

The Plough was once the local courthouse and miscreants guilty of such felonies such as stealing sheep were detained in the cells that are now the pub cellars. The Plough Inn has become a Mecca for National Hunt racing enthusiasts. Opposite the pub is Jackdaws Castle, the racing stables of Jonjo O'Neill. There were wild celebrations in the pub in April 2010 when Don't Push It, ridden by Tony McCoy, won the Grand National at odds of 10-1. Landlord Craig Brown was selected as one of the riders to participate in the John Smith's Peoples Race on Grand National Day in 2009 – he was runner up.

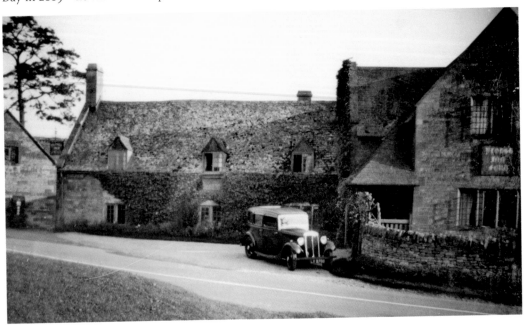

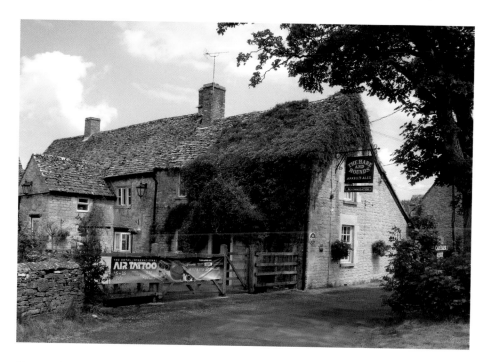

Hare and Hounds, Fosse Cross

The Hare and Hounds, known by regulars as 'The Stump', has been licensed since at least 1772. Cirencester Brewery purchased the Hare and Hounds in 1927, and in the real ale revival of the 1980s it was a popular free house. Arkells Brewery of Swindon bought the pub in September 1998 and, upon refurbishment, a seventeenth-century fireplace and a spiral staircase were found when workmen knocked down the old gent's toilet. Today the Hare and Hounds is renowned for the excellence of its cuisine, with accommodation in ten letting rooms.

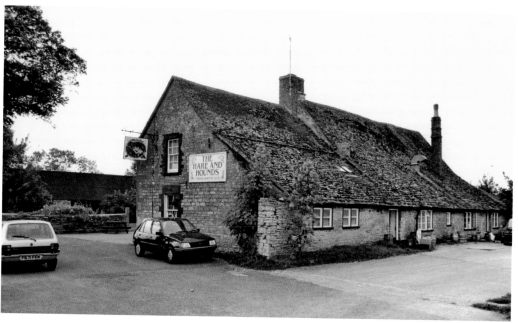

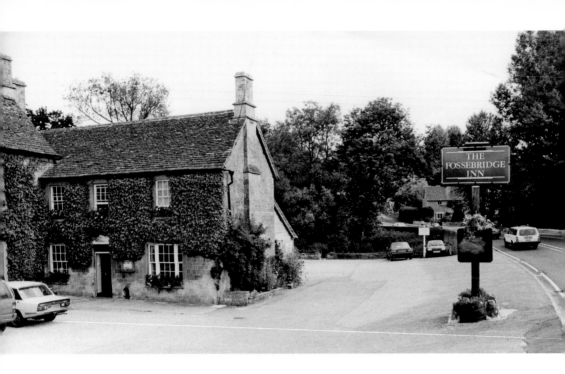

Inn at Fossebridge, Fossebridge

Located at the bottom of the Coln Valley on the Fosse Way (now the A429), the Inn at Fossebridge has been catering for travellers since Tudor times. In May 2003 the owners claimed the business was unviable and submitted plans to Cotswold District Council to close the hotel and convert the premises into eight residential apartments. Following refusal an appeal was lodged whilst the owners were instructed to put the Fossebridge Inn on the market. The application was withdrawn in September 2004 when it became apparent that the hotel was doing a roaring trade.

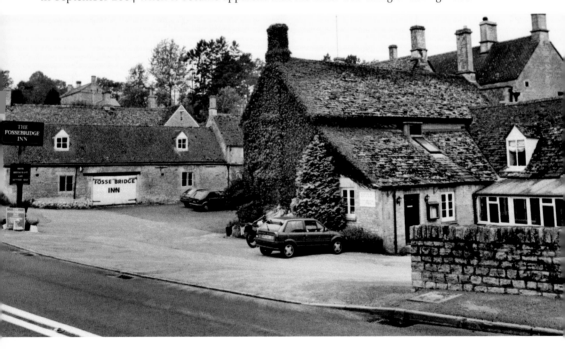

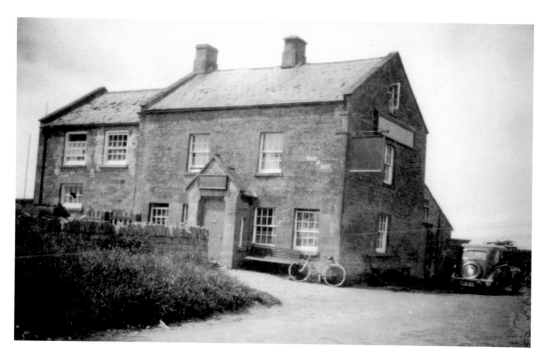

Coach and Horses, Ganborough

Donnington Brewery has two pubs called the Coach and Horses and both are located in the parish of Longborough. Differentiating between them whilst researching their history has been problematic to say the least – which pub was Charles Preston the landlord of in 1891 and 1903? The 'top' Coach and Horses, on the A424 Stow to Broadway road, is the closest pub to the Donnington Brewery and offers a warm welcome, but watch out for Albert the 12-lb pike!

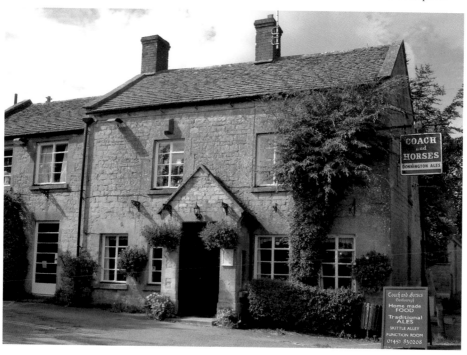

Shutter Inn, Gotherington

It defies belief that a village the size of Gotherington, with a population exceeding 1,000, cannot sustain their only village pub – the Shutter Inn. Yet in May 2012 the tenant landlord surrendered his lease on the property to owning Pub Company Enterprise Inns. The 'Shutters' has seen a succession of landlords come and go in recent years. The question has to be asked what role the avaricious Pubco has had in so many failing personal businesses? If the Shutter Inn was sold freehold to a private individual or family brewery it would be a thriving concern again, an asset to the community.

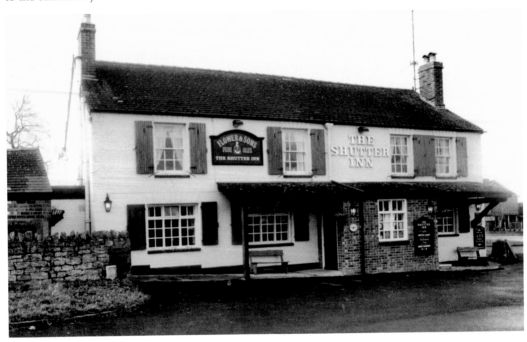

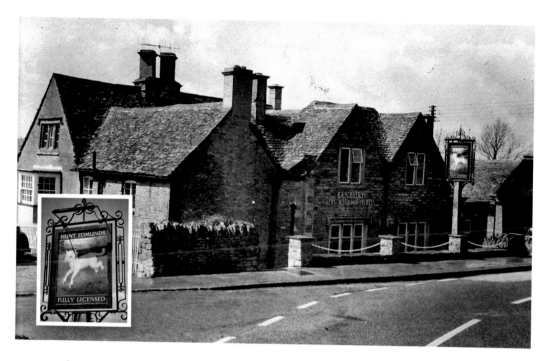

Lamb Inn, Great Rissington

Converted from a farmhouse, the oldest part of the Lamb Inn is over 300 years old. The Lamb was once owned by Hunt Edmunds Banbury Brewery, later becoming a Bass Charrington pub. A free house since the early 1990s, a mini-micro brewery was installed as a trial in November 2008 and a few customers claimed that it was the best beer that they had ever tasted. The Lamb Inn is renowned for its cuisine and in April 2012 a Crabstock Festival was held showcasing the best of seafood from cockles and clams to langoustines and lobsters.

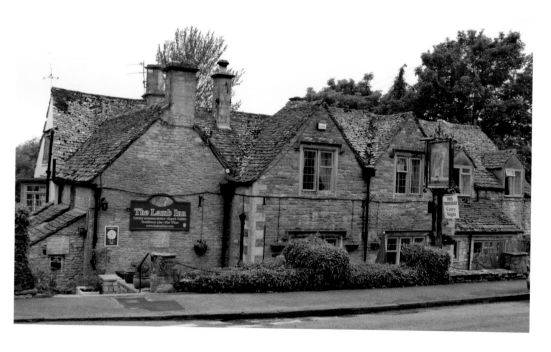

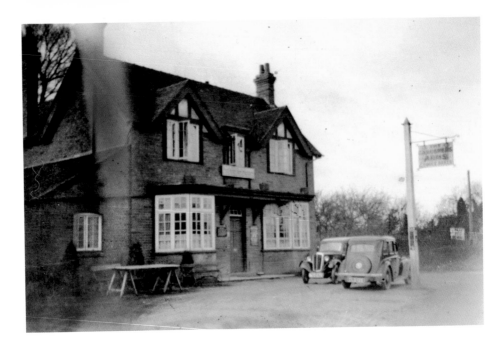

Gardeners Arms, Greet

Whitbread changed the name of the pub from the Gardeners Arms to the Harvest Home in the 1970s. The pub was probably first licensed to cater for the railway navvies who were building the nearby 693-yard-long Greet Tunnel. The Harvest Home overlooks the railway, which is now the Gloucestershire Warwickshire Railway, and steam trains stop at the nearby Winchcombe Station. As the small village of Greet does not have a church building, services are sometimes held in the pub. Appropriately the Harvest Home has been the venue of the annual Harvest Festival.

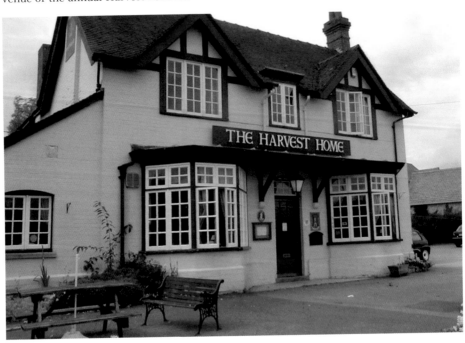

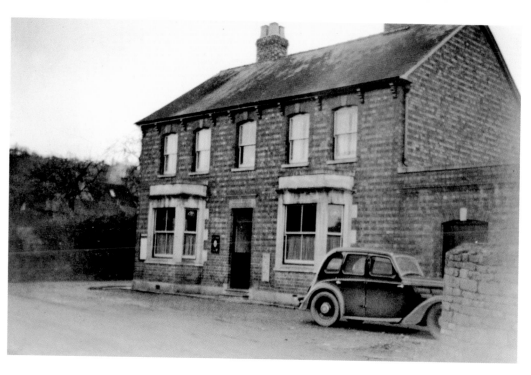

Bugatti Inn, Gretton

Whitbread Flowers held a competition in 1972 to rename their New Inn at Gretton. The name Bugatti Inn was chosen as the pub is near the famous Prescott Hill Climb, home of the Bugatti Owners Club. An article about the pub in the October 1975 edition of *Gloucestershire and Avon Life* concluded that it was an ideal place for motorists to stop for a pint or two after the thrills of the hill races. How times have changed!

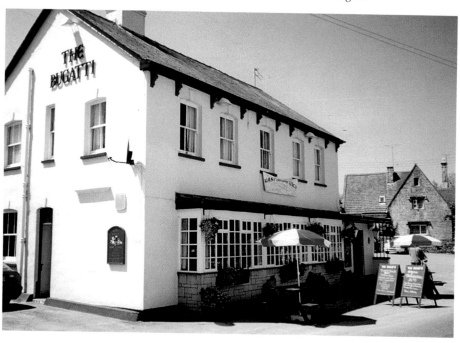

Royal Oak, Gretton

The eighteenth-century Royal Oak was originally two cottages. When it was put on the market in 2000 locals were so determined to save it that they set up a syndicate and bought it for themselves. As the pub is set in two acres of ground, which backs onto the Gloucestershire–Warwickshire steam railway, the owners were keen to maximise its potential. A music and beer festival proved popular but plans to show the occasional film on a large screen during the summer months was misinterpreted by some as an American-style drive in cinema in the Cotswolds.

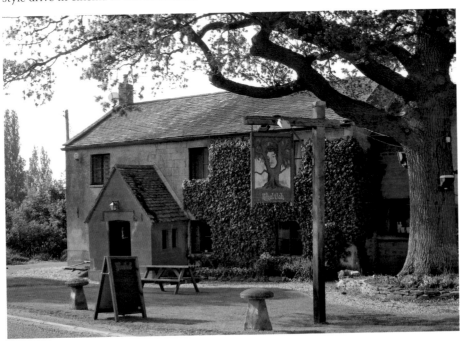

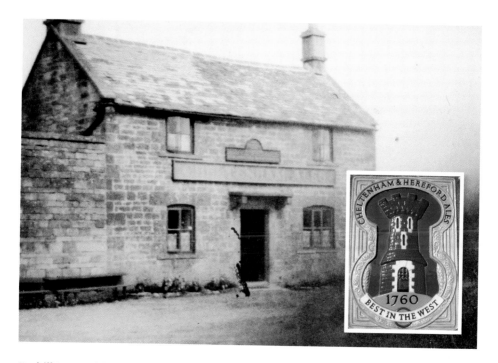

Foxhill Inn, Guiting Power

The Foxhill Inn, although in the parish of Guiting Power, was located in an isolated location on the old Cheltenham to Stow Road (B4068). Originally a small coaching inn with a history going back as far as 1730, it sold beer from Green's Stow-on-the-Wold brewery in 1903. The Foxhill Inn closed in 1995 and the building now offers bed and breakfast. A unique survivor is a Cheltenham & Hereford Ales 'Best in the West' ceramic wall plaque, believed to be the only one remaining in Gloucestershire.

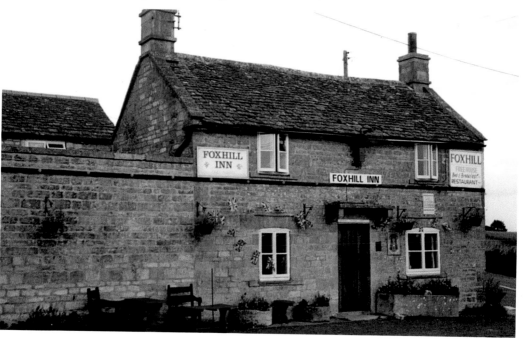

Hollow Bottom, Guiting Power

The Olde Inn was bought in August 1996 by a group of racehorse trainers and owners including Nigel Twiston-Davies and Raymond Mould. The pub was reborn as the Hollow Bottom. In April 1998 Earth Summit, trained by Nigel, won the Grand National. More than a hundred cheering locals and visitors welcomed the winner back home. Nigel Twiston-Davies secured another Grand National win in 2002 with Bindaree, and the jubilant scenes were repeated. But the ultimate accolade, and wildest celebrations, finally came in March 2010 when Imperial Commander won the Cheltenham Gold Cup at odds of 7-1.

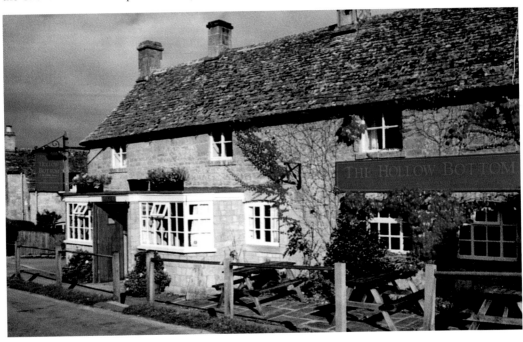

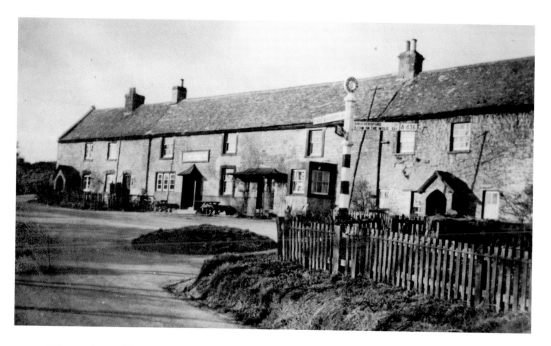

Kilkeney Inn, Kilkeney

The Kilkeney Inn is situated in an isolated position on the A436 Birdlip to Stow Road at the junction with the roads to Andoversford, Dowdeswell and Foxcote. The pub used to be known as the Cross Hands and was once tied to George Stibbs Cheltenham Steam Brewery. A food led establishment by necessity, the Kilkeney Inn closed in 2010 but reopened in June 2012 following a refurbishment by owners Charles Wells of Bedford. During the makeover the last surviving West Country Ales 'castle emblem' iron pub bracket in the Cotswolds was removed.

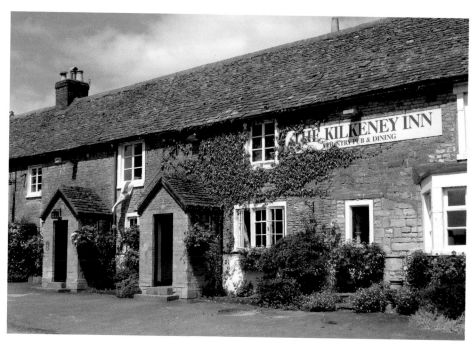

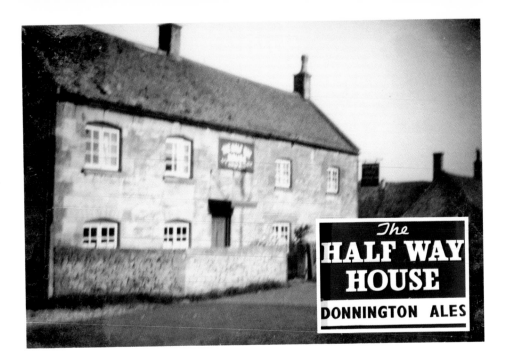

Halfway House, Kineton

The seventeenth-century Halfway House was owned by Corpus Christi College of Oxford and leased to the Donnington Brewery, before being bought outright in 1975. Presumably the name Halfway House refers to the fact that it is halfway between Temple Guiting and Guiting Power ... or Milton Keynes and Monmouth! However, I prefer the version that it is about halfway on the 'Donnington run' – an ambitious pub crawl which aims to visit the fifteen Donnington Brewery pubs in one session.

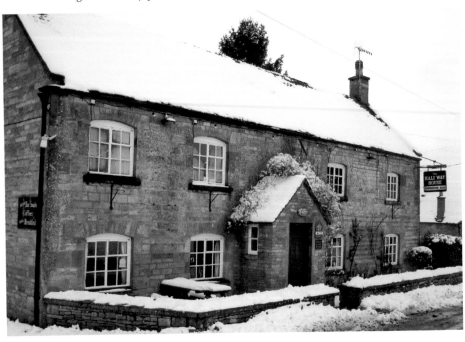

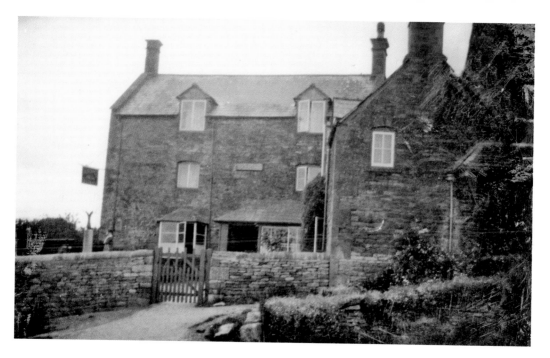

Coach and Horses, Longborough

Most pubs called the Coach and Horses reflect the fact that they were once important coaching inns on strategic main routes. The Coach and Horses in Longborough village certainly doesn't fall into that category. It is a small and homely Donnington Brewery pub. On 1 February 2009 Connie Emm retired as landlady after serving pints of the finest Donnington Ale for forty years. She said: 'I did food in the early days, just sandwiches and ploughman's, but I never wanted a gastro-pub. It's just an old, original village pub.'

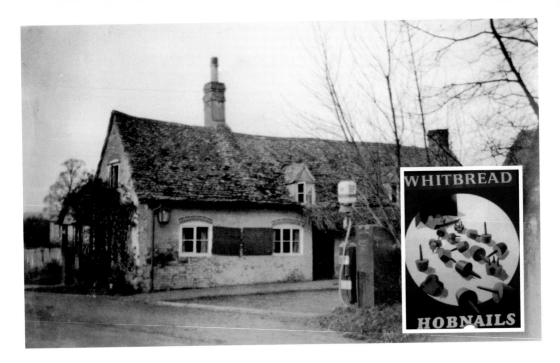

Hobnails Inn, Little Washbourne

The Hobnails was built in 1473. The inn was one of the first pubs to specialise in food. In the early 1950s landlady June Fletcher made steak baps to a secret family recipe and people came from far and wide to enjoy them. Baps were still being served at the Hobnails Inn during the late 1990s. Landlord Stephen Fairbrother even got a nickname – 'Bapman!' The 'Famous Bap Builder' was a bit like a pizza. You could choose a basic filling such as gammon, steak or chicken and then add extra toppings.

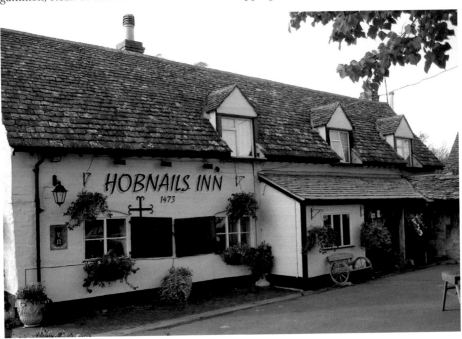

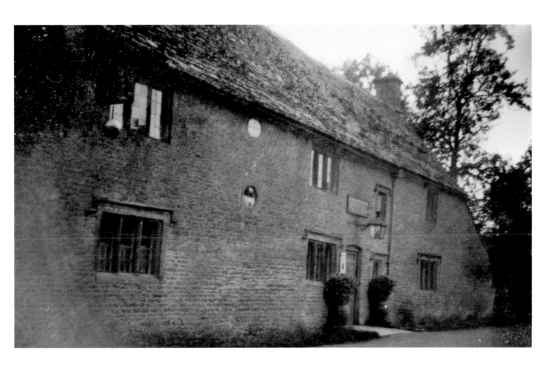

Golden Ball, Lower Swell

The quirkily named picturesque village of Lower Swell is about a mile to the west and down the hill from Stow-on-the-Wold. The Golden Ball, on the B4068, has been serving pints of Donnington Brewery ales for over one hundred years. The Golden Ball won the 2012 *Cotswold Life* Best Neighbourhood Pub award, beating off competition from the other nominated pubs – the Jolly Brewmaster in Cheltenham and the Prince Albert in Stroud.

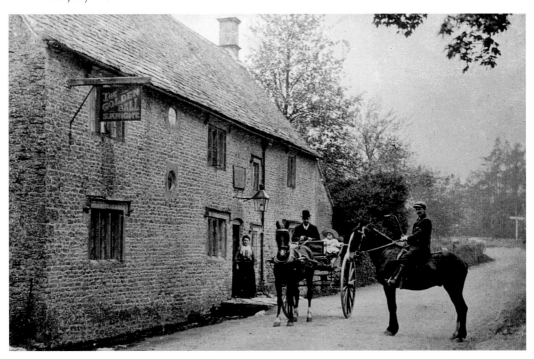

Butchers Arms, Mickleton

Mickleton is in the far north-west corner of Gloucestershire near the Worcestershire and Warwickshire border. The Butchers Arms was one of the few Gloucestershire pubs to be tied to Sladden & Collier's Evesham brewery. Sladden & Co. was acquired by the Cheltenham Original Brewery in 1927 and closed down. The pub, which is still trading, has stone flagged floors and is timber framed. It is reputedly haunted by Hubert the ghost.

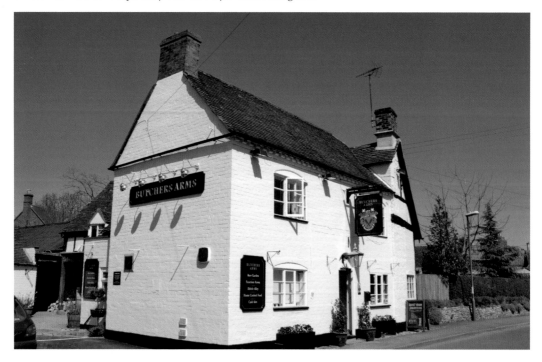

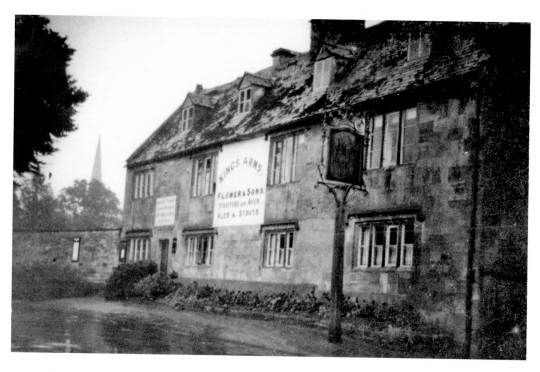

Kings Arms, Mickleton

The Kings Arms is a Grade II listed building that has been operating as an inn since around 1735, and is still highly regarded for its fine cuisine and hospitality. As early as 1891 the Kings Arms was owned by Flowers & Sons of Stratford-upon-Avon, as was the Butchers Arms in 1961. There were once two other pubs in the village – the Milking Pail and the Lamb. The Lamb Inn served beer from Lucas & Co.'s brewery in Leamington Spa.

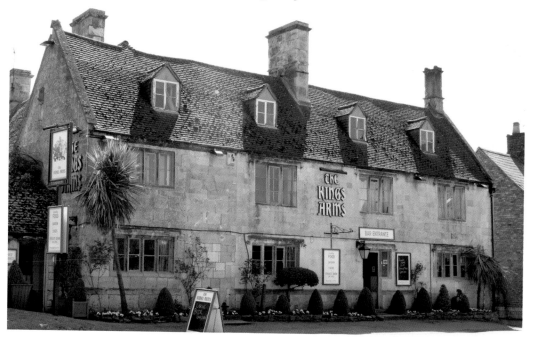

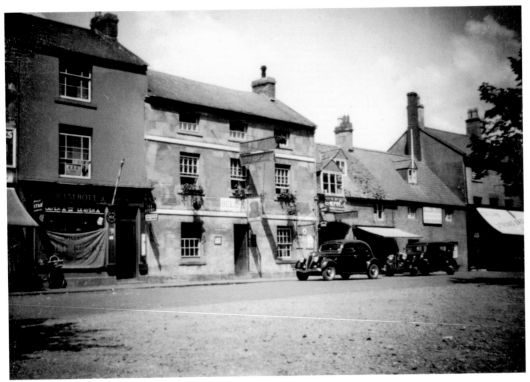

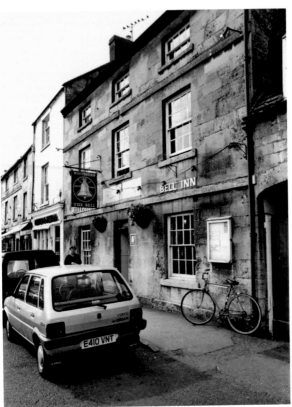

Bell Inn, Moreton-in-Marsh
The Bell is an eighteenth-century ex-coaching inn on the western side of the High Street. The Bell Inn was once tied to William Turner's Caudlewell Brewery in Shipston-on-Stour. Turner's was acquired by Flowers of Stratford in 1896. When intruders broke into the Bell in the summer of 2001 and stole substantial quantities of cash and spirits, landlord Keith Pendry decided to deter burglars by getting a dog, but no ordinary dog – Cody was a 16-stone mastiff that stood a massive 6 foot 6 inches tall when stood on his hind legs.

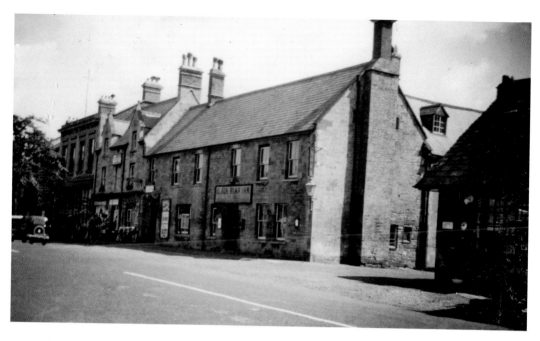

Black Bear, Moreton-in-Marsh

The 300-year-old Black Bear Inn, on the eastern side of the High Street near the Curfew Tower, has enjoyed a long association with the Donnington Brewery. An ex-professional footballer, landlord Jim Steele, was in the Southampton team that famously beat favourites Manchester United 1-0 in the 1976 FA Cup final. Chelsea football legend Peter Osgood, who was also in the winning Southampton side, was a great friend of Jim and often visited the Black Bear before he sadly passed away in March 2006.

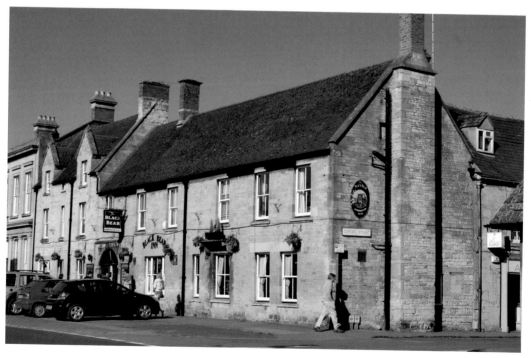

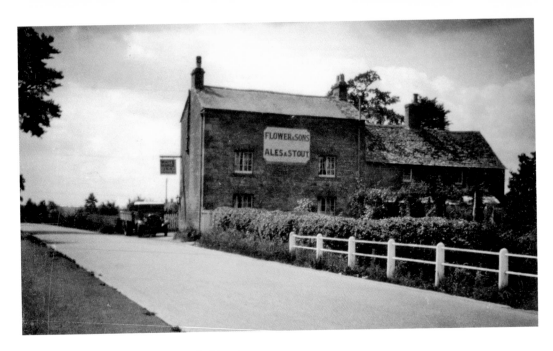

Inn on the Marsh, Moreton-in-Marsh

The Inn on the Marsh, to the south of the town centre on the A429 Fosse Way, was originally the White Horse Inn. In 1891 beers were supplied by the Compton Steam Brewery in Little Compton, before passing into the ownership of Flowers & Sons of Stratford. Marston's Brewery of Burton upon Trent acquired the pub in March 1997. The village duck pond is nearby and every year drakes chase the hens across the busy main road oblivious to the fast moving traffic. Landlord Wayne Brannagh has put up signs outside the pub telling speeding motorists to 'beware of ducks'.

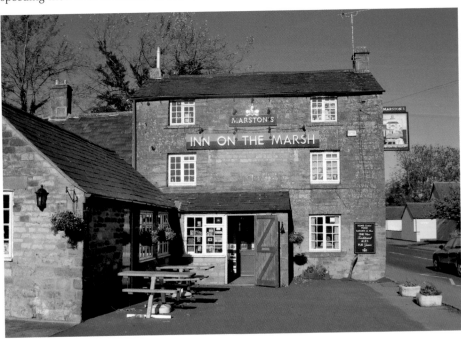

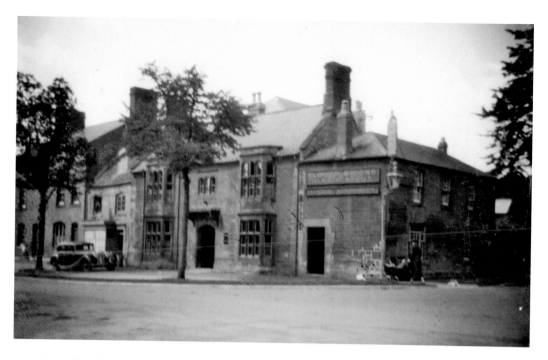

Swan Hotel, Moreton-in-Marsh

Moreton-in-Marsh was a beer drinkers' paradise in Victorian England. Beers from at least eight local breweries could be sampled on a pub crawl around the town in 1891. Donnington Brewery, Dunnell's of Banbury, Flowers & Sons of Stratford, Hitchman's of Chipping Norton, Lardner's of Little Compton, Stow Brewery and Turner's Caudlewell Brewery of Shipston-on-Stour. The Swan Hotel was tied to Tayler's Cotswold Brewery, Northleach, but had been brewing its own beer when Joseph Octavius Gillett was landlord.

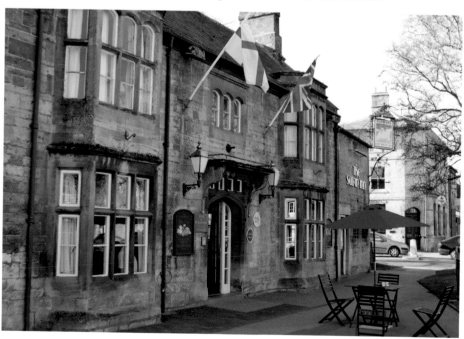

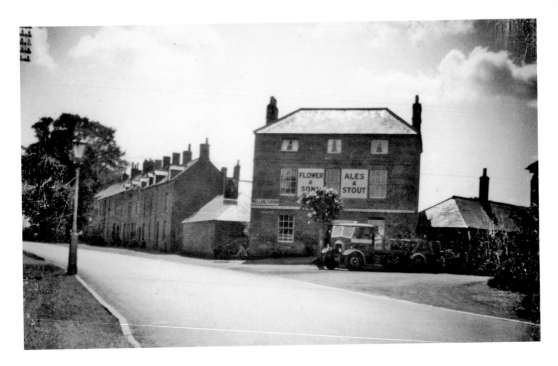

Wellington Inn, Moreton-in-Marsh

In 1891 the Wellington Inn was tied to Lardner's Brewery of Little Compton, which then passed into the ownership of Flower & Sons Stratford-upon-Avon Brewery. After a spell as a Whitbread pub the Wellington was acquired by the Hook Norton Brewery in the mid-1970s. Unfortunately the pub went through a 'rough patch' which prompted Hook Norton to put the pub on the market in November 2010. Acquired by property developers, plans have now been submitted to convert the pub to residential use. However, the Wellington could still be a viable proposition if run by the right management.

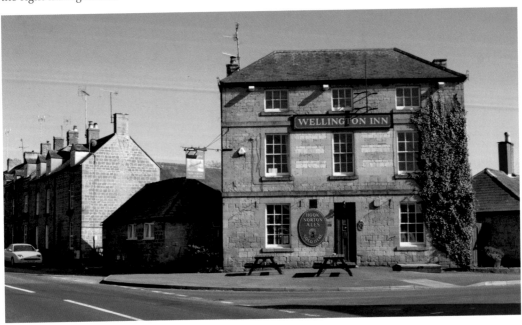

White Hart, High Street, Moreton-in-Marsh

The White Hart Royal is, and always has been, a well appointment hotel. Originally a seventeenth-century coaching inn, King Charles I took shelter in the building following the Battle of Marston Moor on 2 July 1644 and supposedly he didn't pay his bill. When owners the Old English Pub Company put the White Hart Hotel up for sale in April 2007 offers in excess of £1m were invited. A sensitive restoration has retained the character of the building, which now boasts air conditioned luxurious double bedrooms graced with antique furniture.

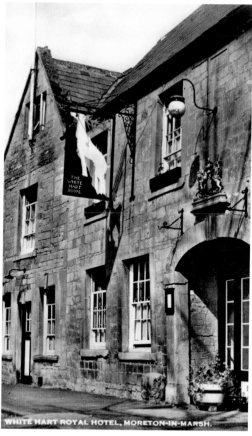

WHITE HART ROYAL HOTEL, MORETON-IN-MARSH.

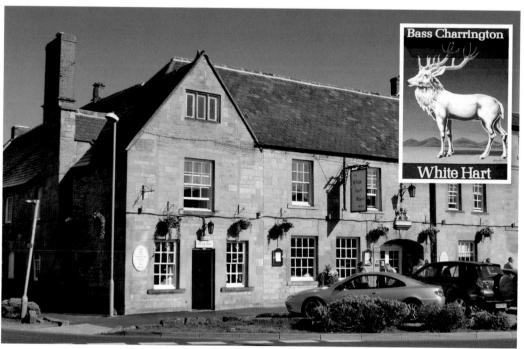

Black Horse, Naunton

The Black Horse is a lovely homely pub in the picturesque village of Naunton. It has been owned by the Donnington Brewery for several generations but there was a time before the First World War when the Black Horse was tied to the rival Green's Stow Brewery. When the landlady of the Black Horse bought two yellow peppers in September 2000 from her local supplier she was somewhat surprised to receive a bill for £10,800 – a computer glitch had charged her for 4,600kg of peppers!

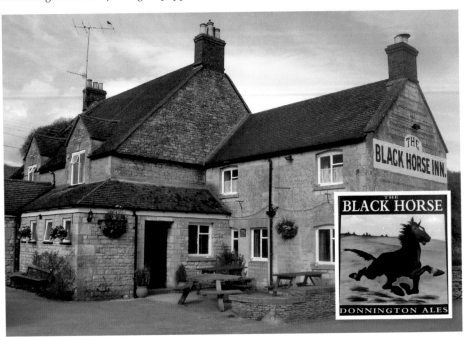

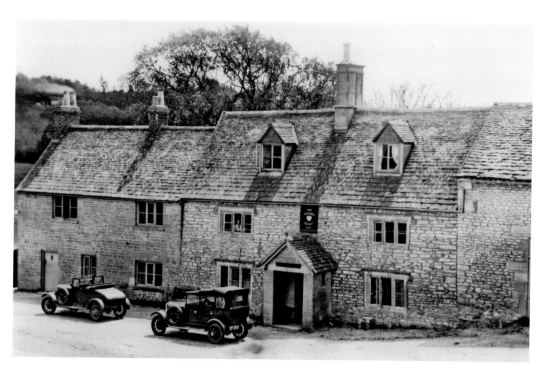

Golden Heart, Nettleton Bottom

The Golden Heart, which dates from *c.* 1540, was originally in the middle of a row of three cottages but the pub has gradually expanded into the neighbouring properties. In 1903 the owner of the Golden Heart was Harry Warner. In the same year a man of the same name was brewing beer at the Norwood Arms Brewery in Cheltenham – perhaps the Norwood Arms once supplied beer to the Golden Heart! History has turned full circle as Cheltenham brewed beers from small craft brewers are regularly on tap at the Golden Heart.

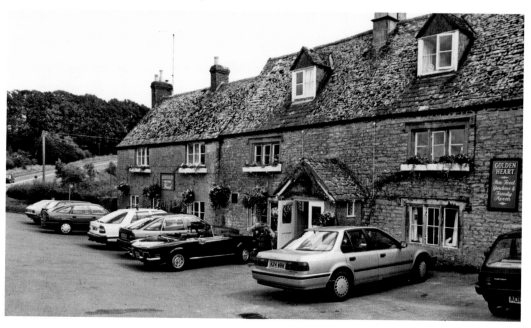

Kings Head, The Peep, Northleach

The Kings Head was a small pub in a terraced row just behind the Market Square. A more grandiose inn of the same name had ceased trading in the High Street by 1840. The Kings Head sold beer from the local Tayler's Cotswold Brewery. In April 1870 landlord William Day was summonsed for keeping his house open for the sale of beer at a quarter to eleven at night, and was fined 10/-, and 9/- and 3d costs. The Kings Head closed in 1909.

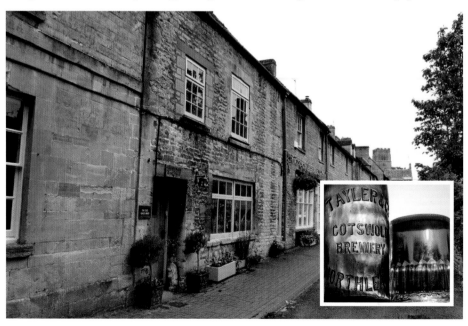

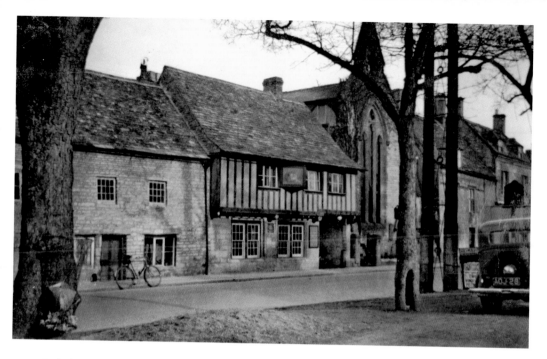

Red Lion, Market Square, Northleach

The sixteenth-century Red Lion was once a Cirencester Brewery pub, subsequently being owned by Simonds Brewery of Reading and then Courage. In the cellar of the pub is a sealed off entrance to a tunnel which is thought to have crossed the Market Square towards the fifteenth-century church. In the summer of 1993 the Red Lion became Britain's first job centre operating from a pub. A notice board in the foyer of the Red Lion displayed about twenty job vacancies, an initiative backed by the Cotswolds Countryside Employment Programme.

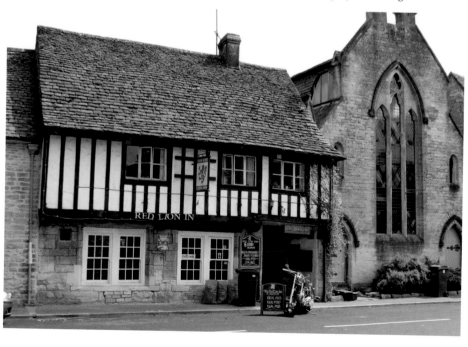

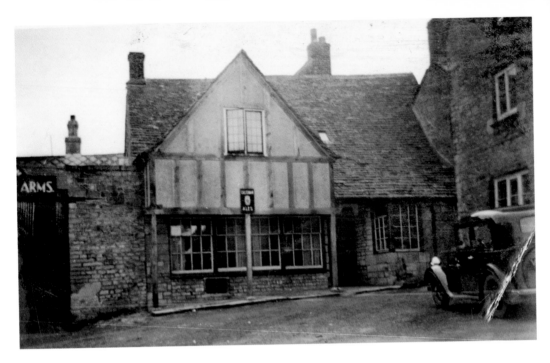

Sherborne Arms, Market Square, Northleach

The original site of the Sherborne Arms was in a row of terraced houses on the eastern corner of Farmington Road. The buildings were demolished to make way for the widening of the road. The present Sherborne Arms is a distinctive fifteenth-century, half-timbered, single-gabled building close to the famous church. It was once the home of a wool merchant whose wealth made Northleach prosperous. The Forge restaurant was formerly a blacksmith's forge.

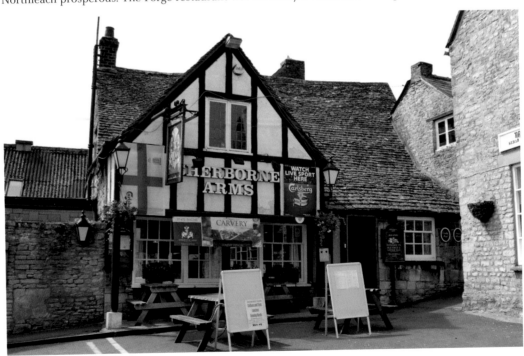

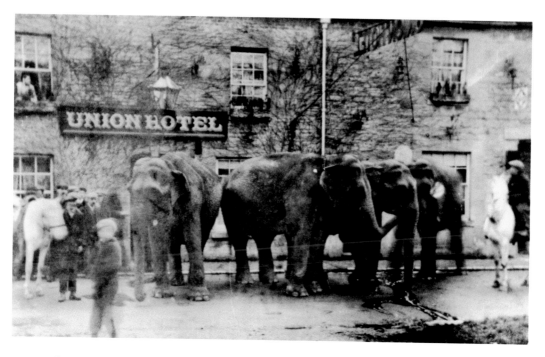

Union Hotel, Market Square, Northleach

The Union Hotel became one of the leading inns in Northleach in the middle of the eighteenth century, poaching trade from the nearby Kings Head Hotel which ceased trading around the same time. In 1885 reference is made to the Union Commercial Hotel. By 1903 the local brewery, Tayler & Co., owned the Union Hotel. It was a meeting place for the Cyclists' Touring Club. The Union closed in 1993 and the property is now a private house. The free standing oval pub sign across the road is now used as the town sign.

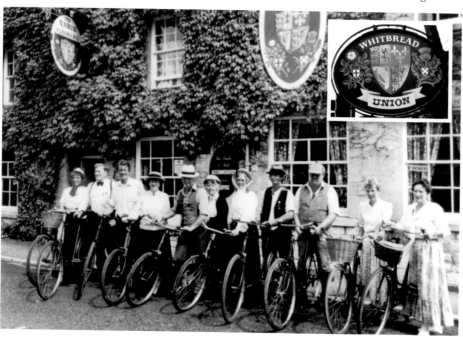

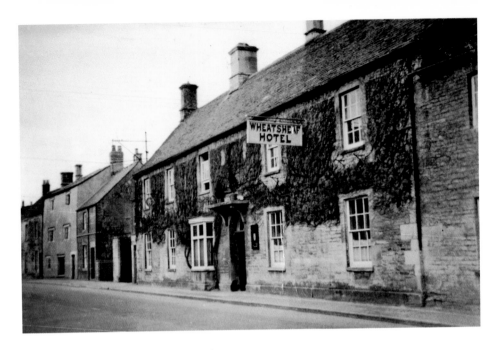

Wheatsheaf, High Street, Northleach

In 2002 an unusual dish was served up at the Wheatsheaf Inn. Chalked up on the menu board were squirrel and foie gras torte with leek and dauphinois potatoes and confit leg of squirrel wrapped in Parma ham on a potato salad. Diners ate their way through an average of twenty-five squirrels a week. However, concern was raised when it was pointed out that between March and July squirrels were allowed to be poisoned as they are considered vermin. The owner said: 'we don't want to poison our customers'.

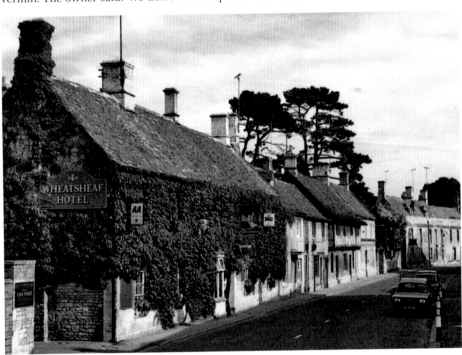

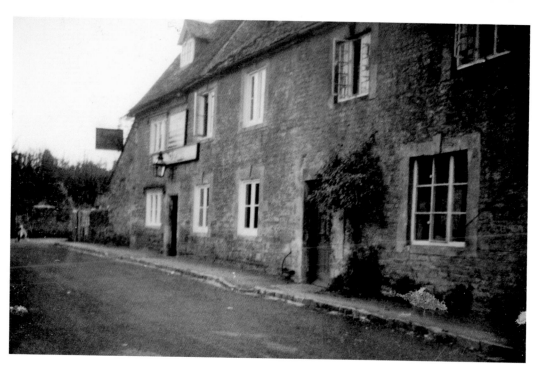

Fox Inn, Oddington

The sixteenth-century Fox Inn was once tied to Hunt Edmunds of Banbury. There is still a rare blue Hunt Edmunds round plaque still *in situ* at the front of the pub, but at the time of my last visit it was covered over with Virginia creeper. Since 2001 the Fox has achieved many accolades for its fine cuisine, being named the first Michelin Pub of the Year, rated amongst the best 1,000 in the country in the *Which? Pub Guide*, and listed as one of the top five hotels in the country in the *Harden's Hotel Guide*.

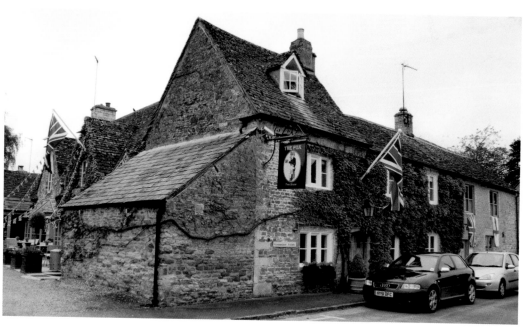

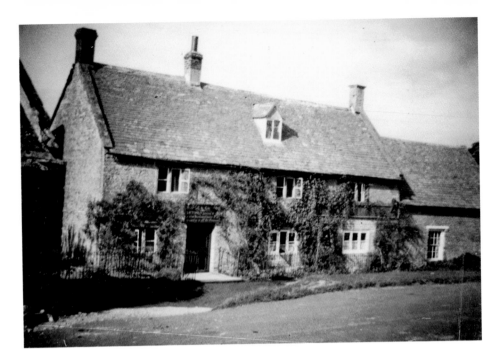

Horse & Groom, Oddington

The sixteenth-century Horse & Groom is in the village of Upper Oddington. In January 1996 the Horse & Groom was on the market for £395,000. Eight years later, following a refurbishment and the addition of seven letting rooms, the inn was on the market for £1.5 million. Owner Simon Jackson said in April 2006: 'We are a village pub. There's a tendency for pubs to be driven by the London market and weekenders, but we're here for the locals.' The Horse & Groom currently features in the *Good Beer Guide 2012*.

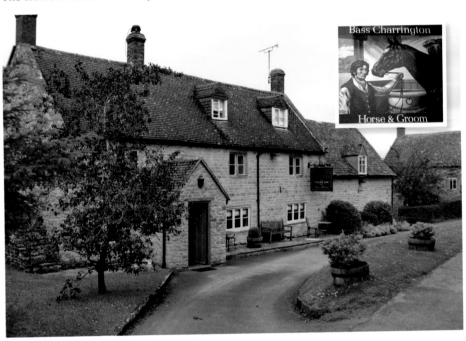

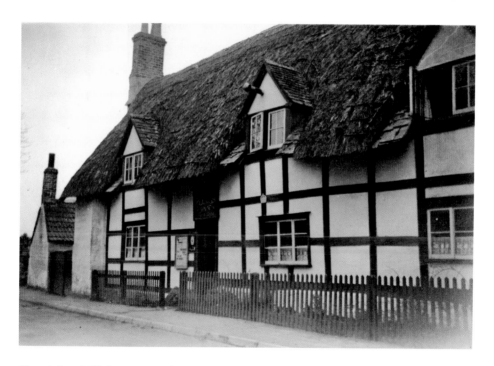

Plough Inn, Mill Street, Prestbury

Tucked away down a narrow lane opposite the village church the Plough Inn is a stone and brick building with a thatched roof – one of the prettiest pubs in Gloucestershire. In summer the hanging baskets outside the pub create an idyllic scene. The Plough Inn is renowned for its cider, still served in ceramic mugs. A local cycling club, aptly named the Scrumpy Wheelers, meet in the pub. They describe themselves as a 'drinking club with a cycling problem'. On Thursday evenings the Plough Inn hosts live folk music.

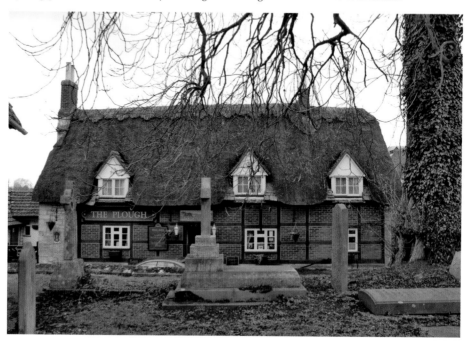

Royal Oak, The Burgage, Prestbury

The Royal Oak has the feel of a traditional Cotswold pub yet it is only a few miles away from Cheltenham. Tom Graveney, ex-England, Gloucestershire, Worcestershire cricketer and BBC commentator, was landlord of the Royal Oak in 1975. Today the Royal Oak serves excellent food and holds a Beer & Sausage Festival every Whitsun and a Cider & Perry Festival on August Bank Holidays.

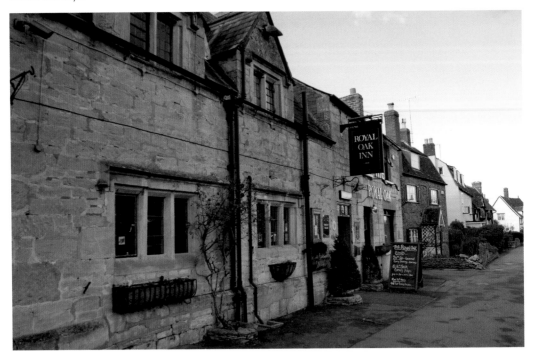

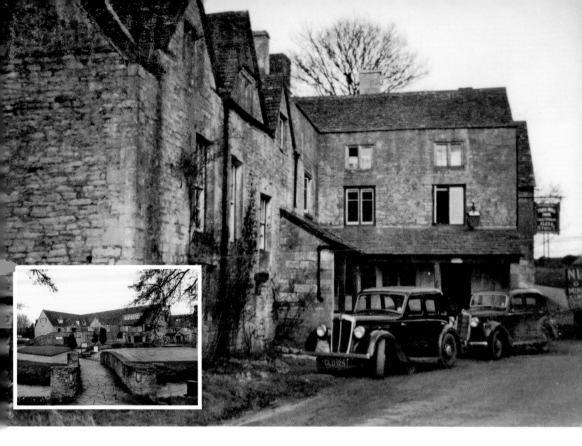

Frogmill Inn, Shipton

The original Frogmill was a working mill dating back to 1068 and it was mentioned in the Domesday Book. It became a coaching inn during the 1600s. The River Coln burst its banks on 20 July 2007 causing extensive damage to the property. The company that owned the Frogmill went into administration, with property consultants putting the 'substantial country inn' up for sale with 'offers in excess of £1.6 million'. The hotel was abandoned for nearly two years, finally reopening for business again on 10 July 2009.

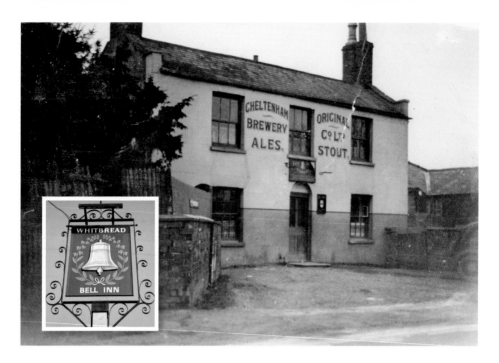

Bell Inn, Shurdington

The Bell Inn was built in 1801 as a small wayside inn and was extended about a century later. For over fifty years from 1890 it was run by one family and also acted as the village bakery. In the early 2000s the traditional bar and lounge were knocked through to create a larger drinking area. The Bell Inn became a restaurant specialising in fish dishes like roasted monkfish on grain dauphinois with lemon and lobster beurre blanc. Thankfully the Bell Inn is now once again operating as a traditional village inn.

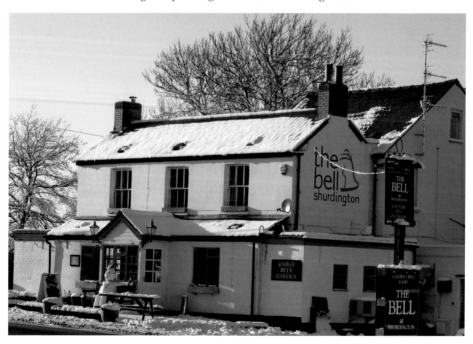

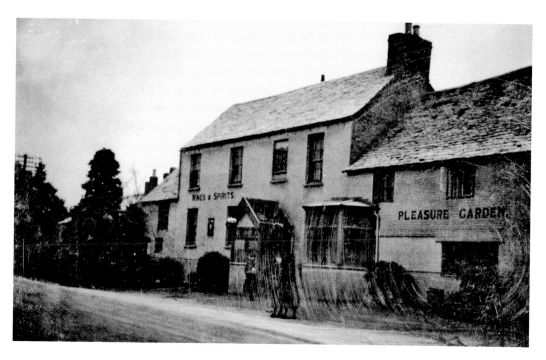

Cheese Rollers Inn, Shurdington

Once the New Inn, the name was changed to the Cheese Rollers in the early 1970s. The Cheese Rolling tradition takes place every Whitsun at Coopers Hill two and a half miles to the south-west of the pub. The tradition involves chasing a cheese down a precipitous 1 in 2 slope, literally head over heels. The fortunes of the Cheese Rollers took a downward spiral in April 2012. Following a dispute with owners Enterprise Inns over their restrictive beer supply and excessive rate demands the landlady gave up her tenancy. In June 2012 it was closed.

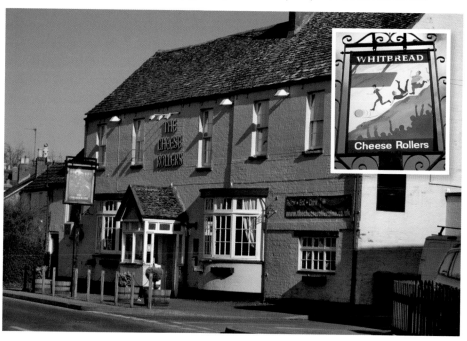

Snowshill Arms, Snowshill

The Snowshill Arms has been selling Donnington beers for several generations, but records show that the pub once brewed its own beer. A deep layer of snow covered part of Snowshill village on a hot summer's day in 2001. This was when Renée Zellweger and supporting cast were filming *Bridget Jones Diary* in the village. Ms Zellweger used a bedroom at the Snowshill Arms for a dressing room and the landlady of the pub, Sarah Schad, briefly appeared as an extra in the film.

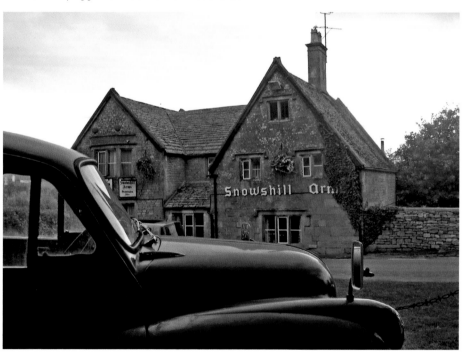

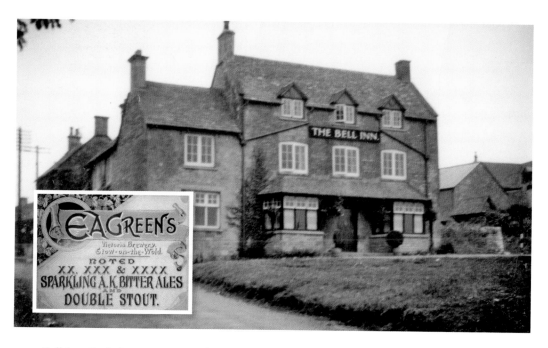

Bell Inn, Park Street, Stow-on-the-Wold

A pub called the Royal Oak was trading in 1767 opposite the Toll Gate. The Royal Oak was rebuilt in about 1850 and re-named the Bell Inn. The occupier in 1891 was Henry Lowther Barker, then the proprietor of the Stow Brewery in Sheep Street. In 2004 the games room at the Bell Inn was dedicated to the late John Entwistle, the bass player of The Who. His artwork and photographs were on display. John Entwistle, who lived just outside the town at Quarwood, died of a heart attack in June 2002.

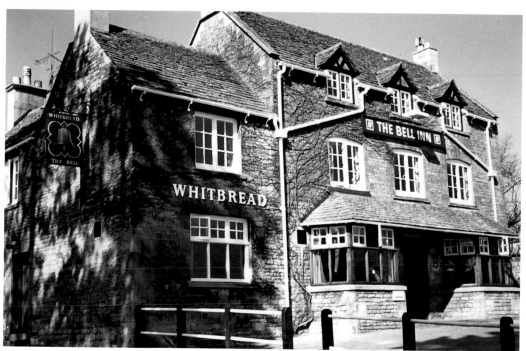

Farmers Arms, Stow-on-the-Wold

The Farmers Arms, at the foot of Stow Hill on the junction with the Fosse Way and Burford road, was once a simple roadside inn. The pub served travellers using Stow-on-the-Wold Railway Station for a hundred years from 1862 to 1962. In the 1990s the property was massively enlarged to create a hotel with seventeen bedrooms becoming the Farmers Lodge Hotel. In the last decade the premises has gone through incarnations as the Roman Court Hotel, Per Amici, Frederick's of Stow and now trades at Number Four at Stow. Cutler's Restaurant occupies the old pub building.

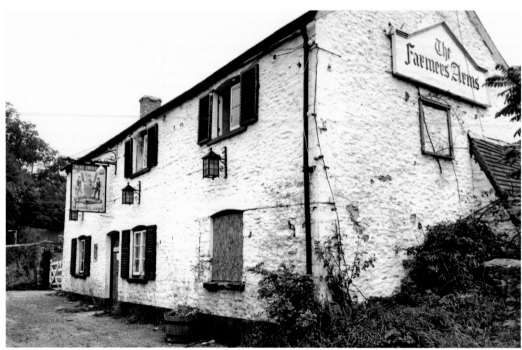

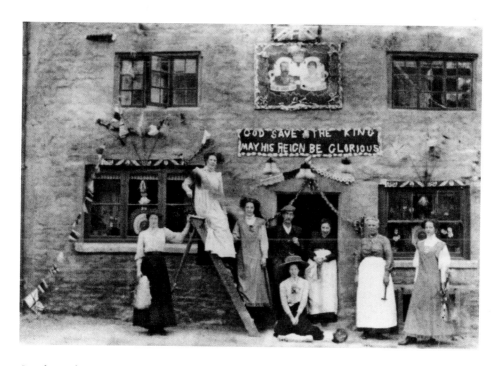

Greyhound Inn, Park Street, Stow-on-the-Wold

The celebrations are for the Coronation of King Edward VII on Saturday 9 August 1902. But is that a decapitated head on the pavement? The licence of the Greyhound Inn was refused when it came up for renewal on 29 March 1909. The Cross Keys on the opposite side of the road closed at the same time along with two pubs in the Square – the White Lion and the Crown & Anchor (next door to the Queens Head). The Greyhound is now a private house called Coniston.

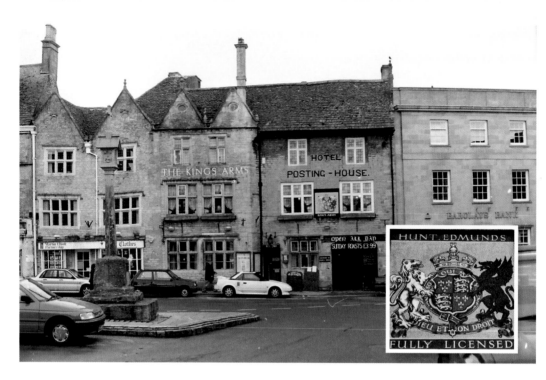

Kings Arms Hotel, The Square, Stow-on-the-Wold

The seventeenth-century coaching inn is reputed to have provided lodging for King Charles I on 8 May 1645, prior to the Battle of Naseby. It was certainly trading as an inn in 1666 and is thought to have gained the reputation of being the best inn between London and Worcester. Robert Harley (later the Earl of Oxford) stayed at the Kings Arms in 1708. The coaching inn had been acquired by Hunt Edmunds of Banbury by 1891.

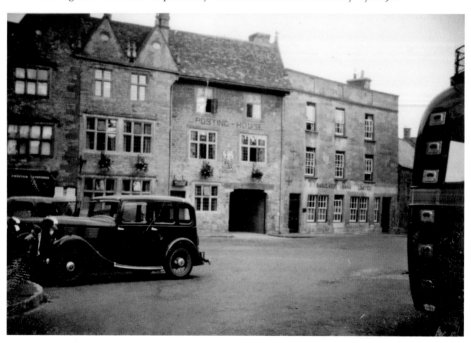

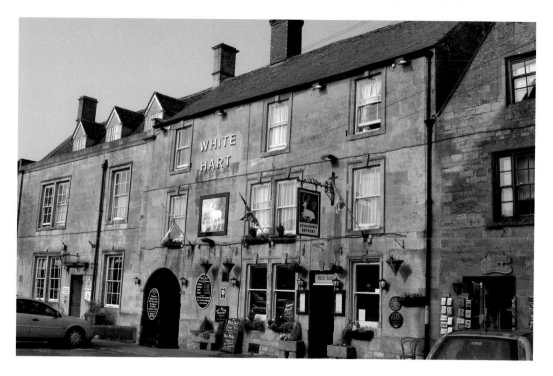

White Hart, The Square, Stow-on-the-Wold

An Arkell's of Swindon house since December 1997, the White Hart was once owned by Hunt Edmunds of Banbury – a round brewery plaque still is *in situ*. During renovations in 2008 a priest hole was discovered in the large front bedroom and two fireplaces that had been hidden away for centuries were uncovered. Controversy ensued during the restoration when access through the old stable doors to the left of the pub was blocked off, leading to several angry demonstrations until a compromise was found.

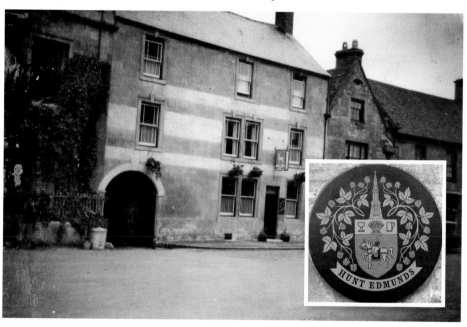

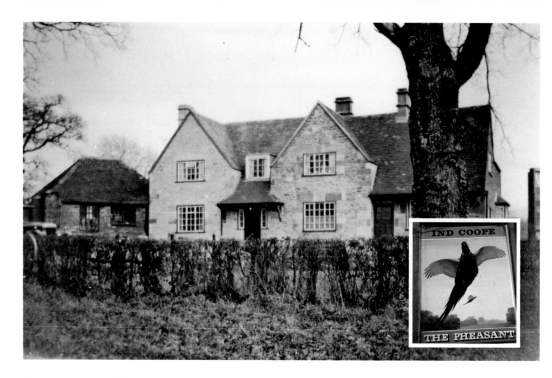

Pheasant Inn, Toddington

The Pheasant Inn is located near the Toddington HQ of the Gloucestershire–Warwickshire Railway. The pub always sells beer from the nearby Stanway Brewery. When Sky News wanted to run a feature on the Campaign for Real Ale's Community Pub Week in Easter 2012 they sent a camera crew to the Pheasant Inn to film the farm animals and ducklings that were on display in the pub car park as an attraction for the children. It was an example of how a pub can attract customers with unusual events.

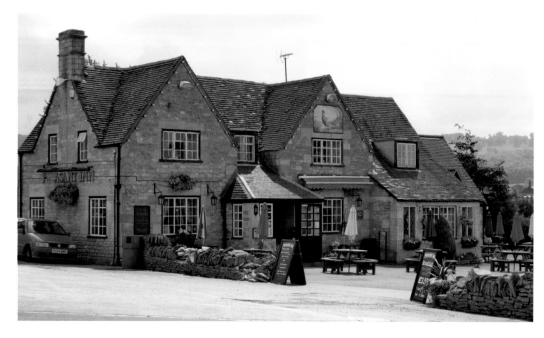

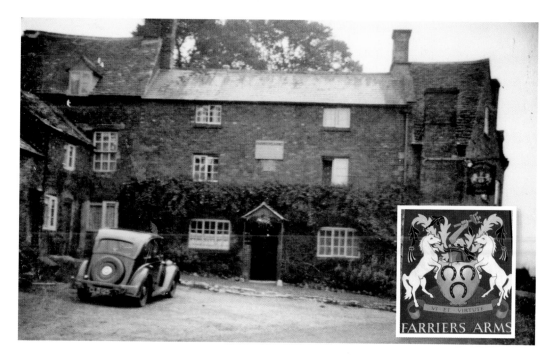

Farriers Arms, Todenham

The village of Todenham is in the far north-eastern corner of Gloucestershire, not far from Shipston-on-Stour. The brick-built Farriers Arms can be traced back to at least 1733 when it was a cottage, garden and smithy. It had become licensed by 1830. The Farriers Arms was purchased by the Little Compton Steam Brewery (Lardner's) on 28 December 1878 for £700.

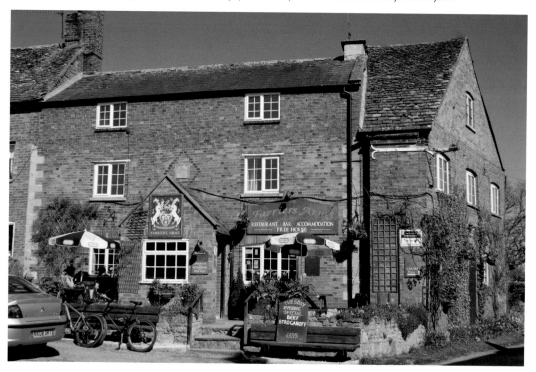

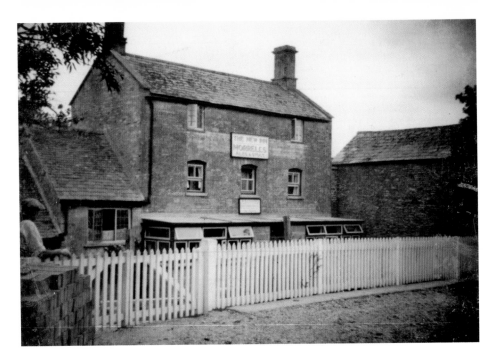

Feathered Nest Country Inn, Westcote

Tied to Green's Stow-on-the-Wold brewery in 1903, the New Inn at Nether Westcote probably passed into the ownership of Morrell's Brewery of Oxford when the Stow Brewery ceased trading in 1914. The New Inn was the only Morrell's pub in Gloucestershire. Unfortunately Morrell's closed in 1998, the family selling the central site off for lucrative redevelopment. The pub became a free house in 2002 and four years later it was renamed the Westcote Inn. In June 2010 the pub was re-launched as the Feathered Nest Country Inn.

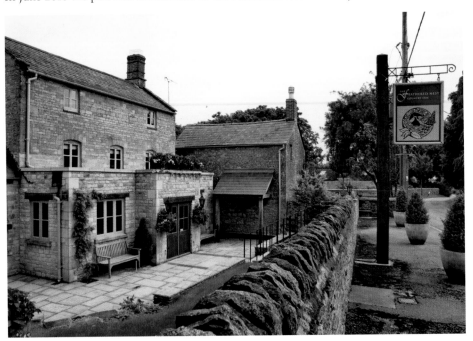

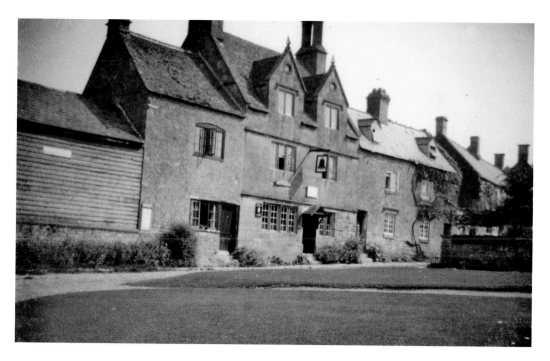

Bell Inn, Willersley

If you travel north on the B4632 from Toddington you enter the county of Worcestershire as you pass through Broadway, but further north in the picturesque village of Willersley you're back in Gloucestershire again – an oddity of the county boundaries. The seventeenth-century Bell Inn, which was originally called the Bluebell, is an archetypal Cotswold stone built pub that overlooks the duck pond. The nearby Norman church of St Peter has a peal of six bells which were cast in 1712. An inscription on the tenor bell reads 'ring for peace merrily'.

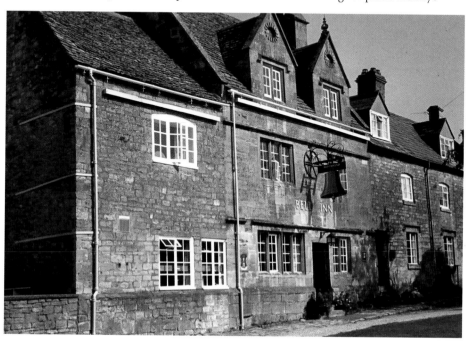

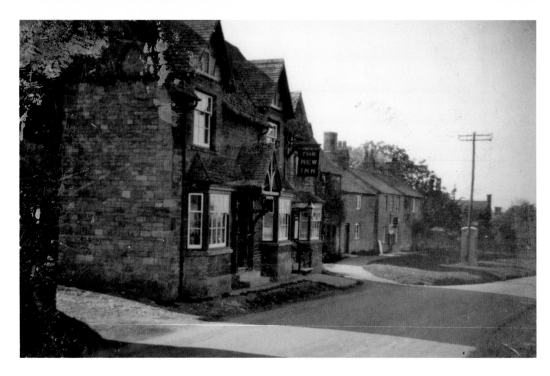

New Inn, Willersley

For well over a century Donnington Brewery have been supplying their beer to the New Inn at Willersley near Broadway. It is about ten miles from the brewery to Willersley, a considerable distance for the horse and dray. At least the steep climb back up the Cotswold escarpment was with empty casks. The New Inn is still very much a locals' pub, it even has a games room and skittle alley rather than a posh restaurant. Joe McDonagh, the landlord, was World Shin Kicking Champion in the 2003 Cotswold Olimpicks.

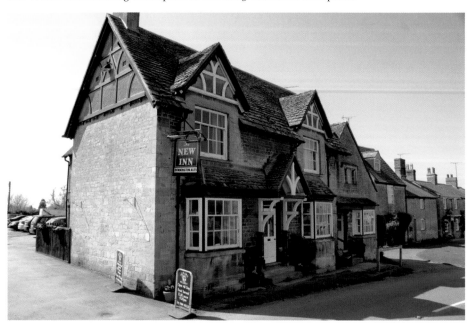

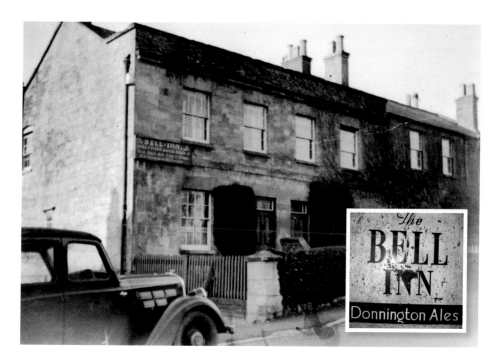

Bell Inn, Greton Road, Winchcombe

When I use to live in Bishops Cleeve in the late 1970s, the Bell Inn at Winchcombe was my local – albeit about an eight-mile cycle ride through Gotherington and Gretton. Walter Morley served excellent pints of Donnington BB. Pub food consisted of jars of cockles and flavoured crisps, and entertainment was courtesy of a 1960s juke-box. After Walter died in 1987 his daughter Diane and her husband Hugh ran the pub, eventually buying it from the brewery. Despite objections, Tewkesbury Borough Council gave permission for the Bell to be converted to residential use in February 2002.

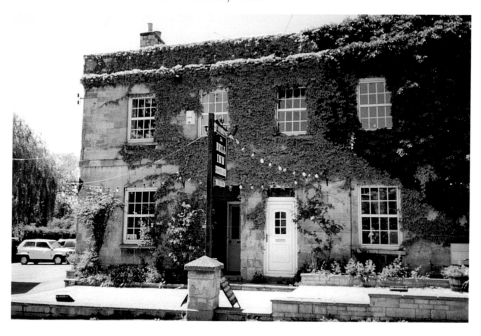

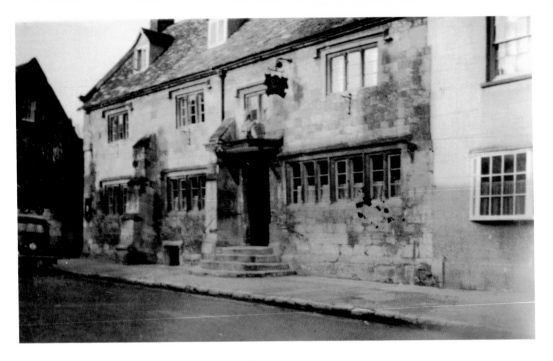

Corner Cupboard, Gloucester Street, Winchcombe

The Old Corner Cupboard is a truly old Cotswold stone building dating from at least 1550. A booklet called 'Gloucestershire Inns', which was published in 1924, gives the following information: 'At Winchcombe's Ye Olde Corner Cupboard, where a head of Disraeli looks out over the entrance, and where a spring of water rises from the cellar floor, and where vaulted underground passages and much old quaint furniture enables the visitor to imagine himself to live in any almost any age, but the present.' Eighty-eight years later the description is still relevant today.

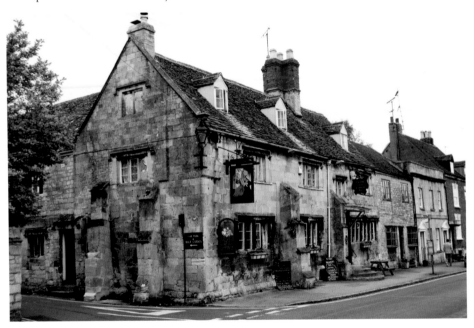

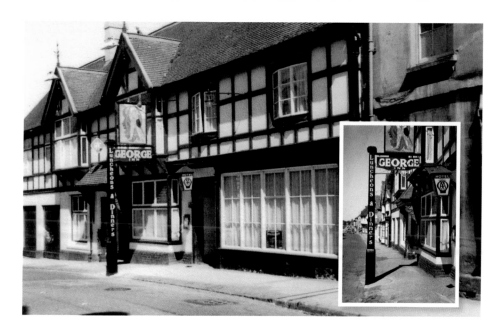

George Inn, High Street, Winchcombe

In medieval times the George was a stopping place for pilgrims travelling to the nearby Hailes Abbey. In 1974 Whitbread published a book featuring 250 of their hotels and a description of the George Hotel noted: 'to this day the George still has the pilgrims' gallery and the stone bath in the yard which they used. The pilgrims' former dormitory is now the fine beamed restaurant, and some of the 16 bedrooms still have the ancient timbers showing. The food is good, the drink is good, the accommodation trim, clean and comfortable.' The George Hotel closed in April 1988.

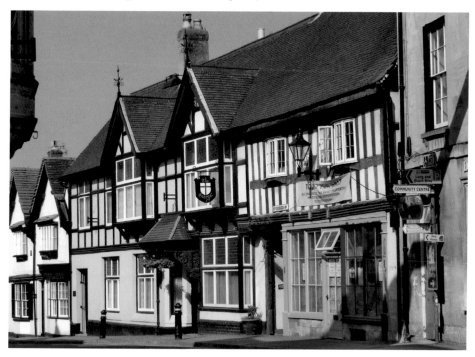

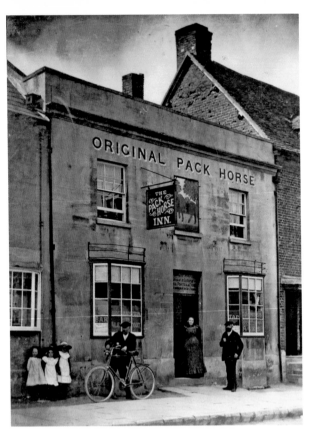

Pack Horse, Gloucester Street, Winchcombe
There were two pubs in Winchcombe called the Pack Horse, both in Gloucester Street and located either side of the Old Corner Cupboard. The Original Pack Horse, also known as the Lower Pack Horse, was at the present day 89 Gloucester Street to the right of the Corner Cupboard. Although probably not visible on the old photograph, the bay windows had advertisements for 'Brockhampton Ales & Stout' and 'Coombes Sparkling Ales'. They were probably disposed of when the Original Pack Horse closed in 1915 – they would be highly collectable today!

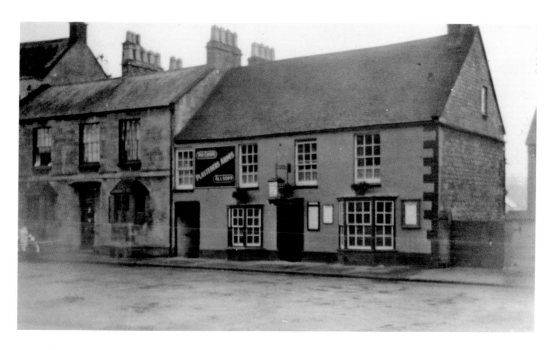

Plaisterers Arms, Abbey Terrace, Winchcombe

The Plaisterers Arms is on the southern side of the Square in the centre of the town not far from the parish church which is famous for its grotesque gargoyles. The pub was once owned by the Combe's Brockhampton Brewery. The brewery and properties were sold to Showell's Brewery in 1921, which amalgamated with Ind Coope & Allsopp becoming part of Allied Breweries in 1963. For many years the Plaisterers Arms sold Ind Coope beers such as Double Diamond but is now a free house selling more interesting beers such as St Austell Tribute and Wye Valley Butty Bach.

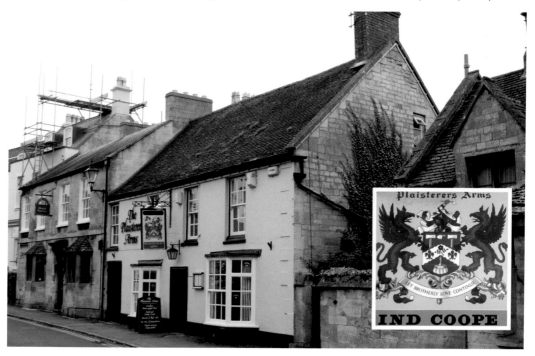

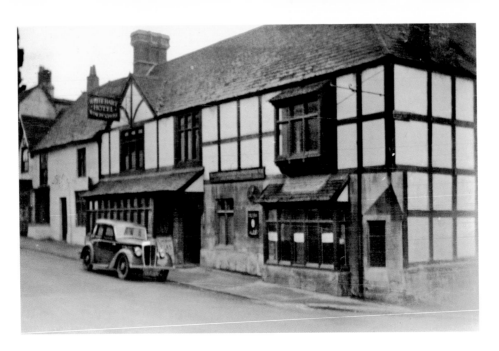

White Hart, High Street, Winchcombe

The sixteenth-century White Hart is located on the southern side of the High Street on the junction with the unclassified road which leads to Sudeley Hill and Guiting Power. Once owned by West Country Breweries and Whitbread, the White Hart is now part of the Hatton collection of hotels. The pub has a 'wine and sausage' restaurant and boasts its own wine shop. Connoisseurs will be interested with the 2005 Pauillac de Château Latour for £59.95 or the 2008 Glaetzer 'Amon-Ra' Shiraz for £49.95.

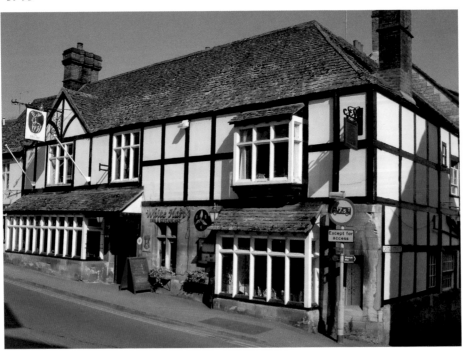

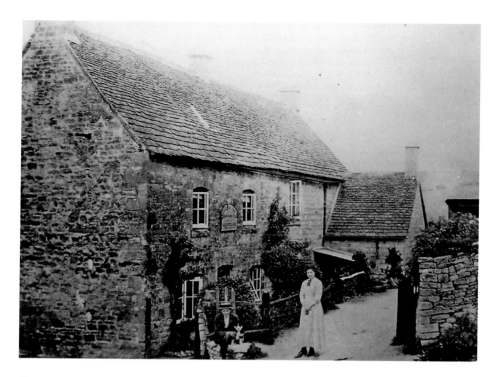

Compasses Inn, Withington

The Compasses Inn was owned by the Cotswold Brewery in Northleach, operating under the family name of Tayler & Co. A valuation of the brewery and its property in November 1911 gave notice that the Compasses beer house in Withington was doing a trade of seventy-two barrels a year and the tenant was paying £10 rent. The property was valued at £570 and the entire estate was estimated at £18,145. Cheltenham Original Brewery acquired the business and the Compasses closed in 1924, the old inn becoming the village post office.

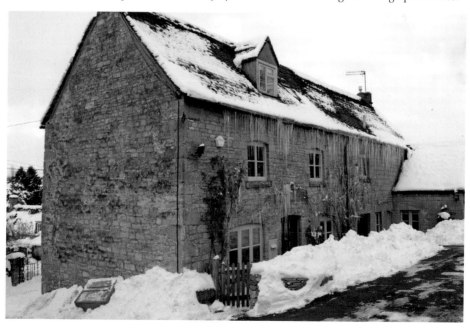

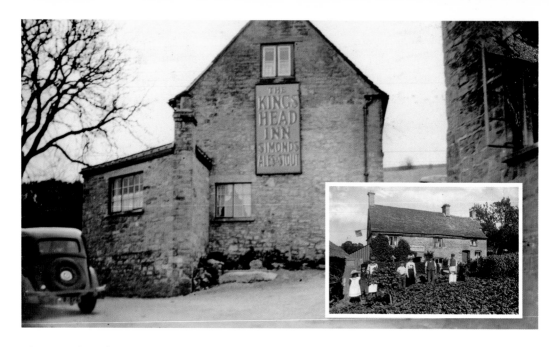

Kings Head, Withington

After leasing the Kings Head for a number of years, the Cirencester Brewery Company purchased the pub on 25 November 1926. Ernest and Bessie Griffin came to the Kings Head in 1912, initially on a short stay basis. In 1929 they had a daughter, Coralie, who was born at the pub. Coralie married Peter Taylor and in 1956 they were running the Kings Head. Incredibly fifty-six years later Mrs T., as she is affectionately known, is still the landlady of the pub – helped by her sons Martin and Donald and her springer spaniel Tilly.

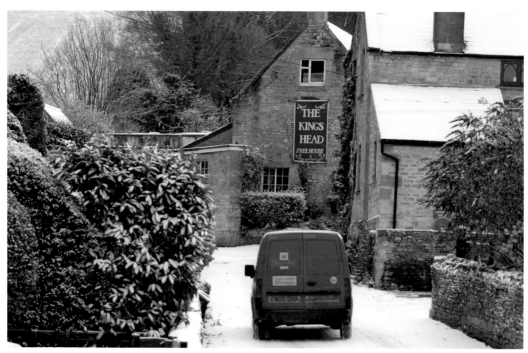

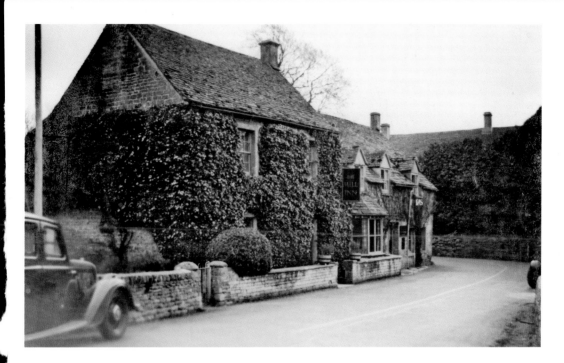

Mill Inn, Withington

The Mill Inn is a wonderful unspoilt Cotswold pub, full of character with a warren of small rooms. Its picturesque location beside the River Coln is pure picture postcard stuff. In the 1960s and 1970s the Mill was packed every night with customers enjoying its legendary chicken in the basket meals. In 1990 it was acquired by the Yorkshire brewers, Samuel Smith. At the time there was jubilation as they are family owned company with a great tradition and heritage. Regrettably they now refuse to sell real ale at the Mill and their uninspiring food menu is of great concern.

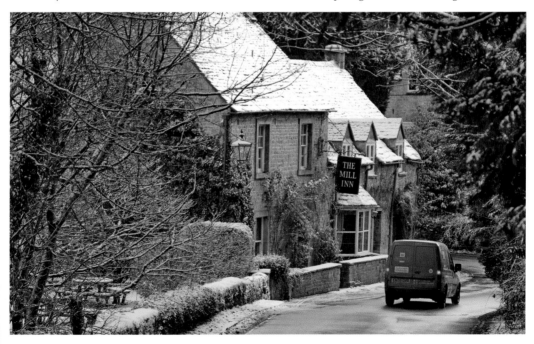

Apple Tree Inn, Stockwell Lane, Woodmancote

The eighteenth-century Apple Tree, at the foot of Cleeve Hill, is now owned by Greene King. In the 1950s, when it was owned by Flowers Stratford-upon-Avon brewery, the British Legion organised fêtes in the adjoining field and orchard. These events were very popular and featured crowd pulling attractions such as a high wire motorcycle display team, and a 'dive of death' stuntman leaping from a specially erected scaffolding tower into a large tank of water. The most exciting event in recent years is a sponsored bungee jump in the pub car park.

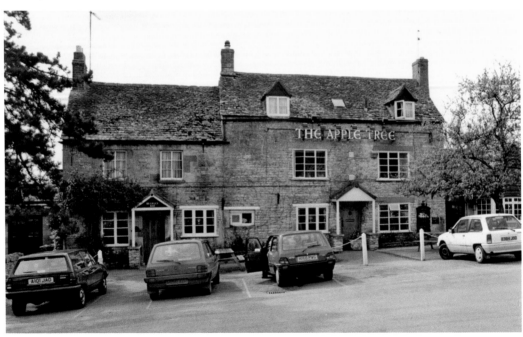